For my father

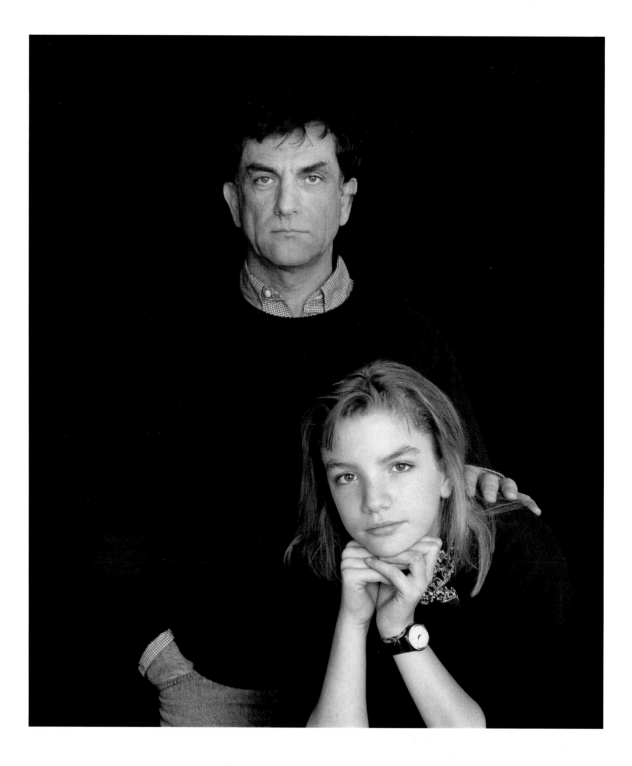

Isi and Judith Beller

Paris, 1992

Introduction by William Styron

Photographs by Mariana Cook

fathers and daughters

in their own words

CHRONICLE BOOKS

SAN FRANCISCO

Library of Congress Cataloging-in-Publication Data

Cook, Mariana Ruth.
 Fathers and daughters : in their own words / photographs by Mariana
Cook ; introduction by William Styron.
 132 p. 246 x 305 cm.
 ISBN 0-8118-0648-0 (hc) ; ISBN 0-8118-0619-7 (pbk)
 1. Portrait photography. 2. Fathers and daughters—Portraits. 3. Fathers
and daughters—Family relationships. I. Styron, William, 1925– . II. Title.
TR681.F33C66 1994
779'.26'092—dc20 93-31739
 CIP

Designed by Laura Lovett
Printed in the United States of America

Distributed in Canada by
Raincoast Books
112 East Third Avenue, Vancouver, B.C. V5T 1C8

10 9 8 7 6 5 4 3 2 1

Chronicle Books
275 Fifth Street, San Francisco, CA 94103

table of contents

———

Introduction by William Styron

7

———

Portraits

13

———

Afterword by Mariana Cook

130

———

List of Portraits

131

———

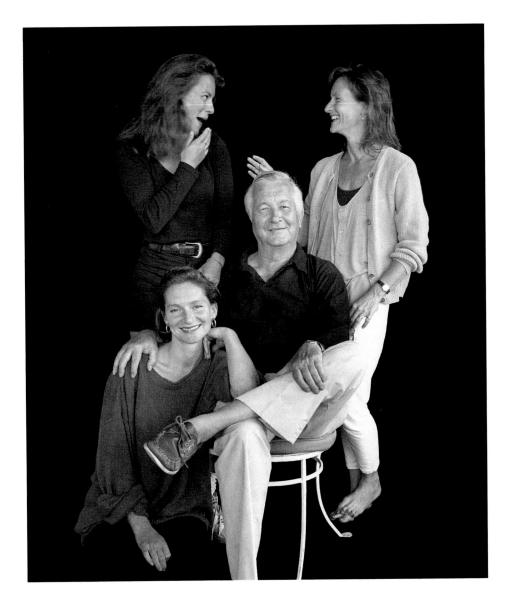

Introduction

by William Styron

The relationship of fathers and daughters

has been a significant theme in world literature. Consider the stage alone. The

theme has arrested the attention of playgoers at least since the time of Sophocles

and Euripides, who wrote of the intertwined fates of Oedipus and Antigone, and of

Agamemnon and Electra. In a companion play Euripides told of how the tormented

Agamemnon was forced to appease the wrath of the goddess Artemis by sacrificing

another daughter, Iphigeneia. One of the most anguished cries in an ancient theater

renowned for its anguished cries is that of Iphigeneia in Tauris: "My life hath known no father, any road to any end may run!" Shakespeare's world teems with father-daughter groupings, of which King Lear and his confounding bevy of girls make up only the most famous. Think of *Hamlet*'s Polonius and Ophelia, the Duke and his Rosalind in *As You Like It*, the great Athenian and his Marina in the eponymous *Pericles*, Shylock and Jessica of *The Merchant of Venice*, *The Tempest*'s lyrically linked Prospero and Miranda.

In modern times one has only to remember Alan and Lavinia in O'Neill's *Mourning Becomes Electra* or Boss Finley and his daughter in *Sweet Bird of Youth* by Tennessee Williams or Shaw's *Major Barbara*, whose title character is the offspring of the unforgettable Undershaft. The connection is there in much European and American fiction: Hardy's *Far From the Madding Crowd*, Victor Hugo's *Les Misérables* (Jean Valjean and Cosette, his surrogate daughter, were among the first fictional characters I ever encountered), Faulkner's Flem and Eula Snopes. In modern poetry two instances of the kinship come quickly to mind: John Crowe Ransom's poignant *Bells for John Whiteside's Daughter*, in which a father's grief for his dead daughter is expressed by the poet's voice and, somewhat perversely perhaps, the later poems of Sylvia Plath, which articulate a discomforting daughterly rage against daddy.

In brooding over this remarkable portfolio of photographs by Mariana Cook, which includes my own familial cluster, I was reminded more than once of how the theme of fathers and daughters gained a prominent place in my work over the years. In the early 1950's, quite some time before I had a daughter myself, I finished a first novel, *Lie Down in Darkness*, which is in large part the story of a father's obsessive love for his firstborn girl, a love which may have had (according to some critics) incestuous overtones but which in any case helped precipitate her early death by suicide. I was quite young—twenty-five—when I completed this book and, as I say, had no experience in parenting; still, putting aside the incest motif (which was always problematical anyway), it was the emotional interplay between father and daughter which I believe was among the most successfully rendered parts of the book. I like to think that such imaginative empathy helped prepare me for the real role of being father to three daughters.

Whatever, the theme never really left my consciousness and in fact reappeared, somewhat menacingly, in my later novel *Sophie's Choice*. There I attempted to create a relationship in which the father's attitude toward his daughter—harsh, judgmental, and authoritarian—could be seen as part of a complex metaphor for Polish anti-semitism, through which, at Auschwitz, Sophie and her children became the unintended but certain victims of that vicious oppression of Jews her father so passionately espoused. Thus, though her doom and that of her children

had its origin in other causes, it was truly sealed by the absence of that affection and decency that binds father to daughter, daughter to father, and both to the natural world.

American fathers possess a peculiarly bifurcated attitude when it comes to the matters of gender in their offspring. Fathers, in other words, are supposed to be loving and supportive toward their daughters, but both the joys and burdens of parenthood fall chiefly upon the mother. This concept springs from a culture in which masculinity and femininity are polarized to a rather intense degree; a father may be profoundly fond of his daughter, but to immerse himself too thoroughly in his daughter's concerns is to risk emasculation, or at least a form of sissification. Better that he focus his interest on a son, or sons. Many cultures have practiced the infanticide of daughters (it is still shockingly prevalent in parts of India), and while our own overall view of the worth of a child's gender is, largely speaking, free of prejudice, it is still a matter of jocular folklore that a son is to be preferred. The celebratory cigars and the joyous announcement, "It's a boy!" composed a ceremony that spoke volumes, at least until recently, when our changing mores would make it appear appallingly sexist.

Traditionally, fathers have preferred to beget sons rather than daughters. The chief reasons for this desirability are embedded in the generally patriarchal nature of human society stretching back to pre-antiquity: sons carry on the family trade or craft, continue to make the money, are the entrepreneurs and explorers, the movers and shakers. Daughters, necessary for procreation, nurturing and housekeeping, fulfill a lesser role; to all but the most intransigently hidebound fathers, girls are welcome all the same, and are even greatly beloved. This is monumental condescenion but it is also a measure of history's cruelty that for most of its course such has been the prevailing view.

What a pleasure it was for me to step outside history and greet my three daughters when they arrived during the decade between the mid-1950s and the mid-1960s. First, there was Susanna. In her pre-natal months (this was before amniocentesis might have permitted me to divine her sex), I lived in a state of happy ignorance as to what I might expect on the day of genesis. I was also honestly indifferent as to whether I might be presented with a boy or girl. Insofar as the baby's sex was concerned I must admit, however, to a small prickling of self-concern, so that when the doctor announced "It's a girl!" I knew I'd be relieved of certain obligations. I knew I would not be expected to go hunting or to play softball or involve myself companionably at any deafening spectator sport, especially professional football, which I despise.

Susanna is the young lady in the top right of Mariana Cook's vivid series of photographs. I'm astonished when I think that this immensely poised and accomplished person is the same

human being, *in extenso*, as the squirming pink and squalling bundle of flesh I beheld for the first time, my heart pounding with apprehension and wonder, in the days of my own hopeful youth. I have no favorites among my delightful daughters but one's firstborn commands a special place in memory, if only because the very novelty of her presence provoked an exquisite concern. What was she crying about? What about that cough? I was always worried about her health, and was in constant consultation with the era's guru, Dr. Spock. I needn't have worried. She was as spunky and resilient in those days as she now triumphantly appears.

If I were to write a verse about Polly, daughter number two (seated at my knee), it would be to rhyme her name with melancholy. She has a dark streak of this mood, inherited from me, and has fought at least one tough battle against it, but lest one think it might have been a ruinous burden to her, or afflicted her in some unyielding way, these confident and humorous eyes should put the idea to rest. Again, those early years are hard to reconcile with the present image but I keep remembering a droll fact of her babyhood: she produced the loudest sounds ever heard in a small human being. These shrieks were not a product of her melancholy but of her lung power and healthy rage, lusty fishmonger's cries totally at odds with the image of the grown young woman, soft of speech, a slim dancer of remarkably supple grace.

Alexandra, the youngest (top left), is a young lady of saucy wit, pleasantly rambunctious, one whose adhesive good humor (though she, too, has a dark side) has kept the family sanely united at

William, Paola, Alexandra, and Susanna Styron
Writer / Dancer / Actress / Filmmaker
Martha's Vineyard, Massachusetts, 1991

moments of stress. She is an actress, and Mariana Cook has captured the gleams of expressiveness that help make her a very good one. Al came late to the family and therein lies an instructive tale. We must remember, while we're on the subject of daughters, that there are also sons. Tom, my only boy, was born shortly after Polly, and became odd man out in a family which, except for the pater-familias, was exclusively female, including dogs, cats, birds, and even boa constrictors. Gentlemen do not have an entirely carefree time in such an environment.

Tom pined during most of his first seven years for a baby brother, and I'll never forget the note of piping grief and anguish in his voice when, calling him from the hospital after Alexandra's birth, I told him he had yet another sister. ("Daddy! *Daddy*, no!") I rather feared for his sanity when the next day, en route to his little workshop in the cellar, he asked me for the following items: rope, nails, a piece of lead, a sharp blade. I was certain he was building a torture device for his baby sister. But in fact, after a long and sinister silence, he emerged with a wondrous artifact: a wooden bird with metal wings, a gift for Alexandra, and tribute to the fact that even he, after all his isolated maleness, wished to celebrate the arrival of another sister, my new daughter. He does not, of course, belong in these pictures but I can't help seeing his ghostly outline here, smiling as he fills out the family portrait of a kind of obverse King Lear, composed and untormented, in the company of his joyous and (one hopes) grateful daughters.

Mariana Cook has, in this portfolio of pictures encompassing so many fathers and daughters, achieved a substantial miracle of photography. There is not only a remarkable clarity of technique and vision, but an ability to capture the nuances of relationship; one can assume

that these moments, electric and vivid, are created out of that intuitive grasp of the revealing instant possessed only by the most accomplished artists. There is nothing lax or dilatory in any of these pictures; each has both precision and luminosity, and in each of them one can perceive the nearly visible energy that flows from the intimacy of kinship. That all of these images and arrangements are not entirely harmonious, nor without emotional tension, adds to their appeal, and to their honesty. What matters is the poetic grace with which the artist has arrested for a moment the humor, the tenderness and, most often, the love that underlie one of the best of all human connections.

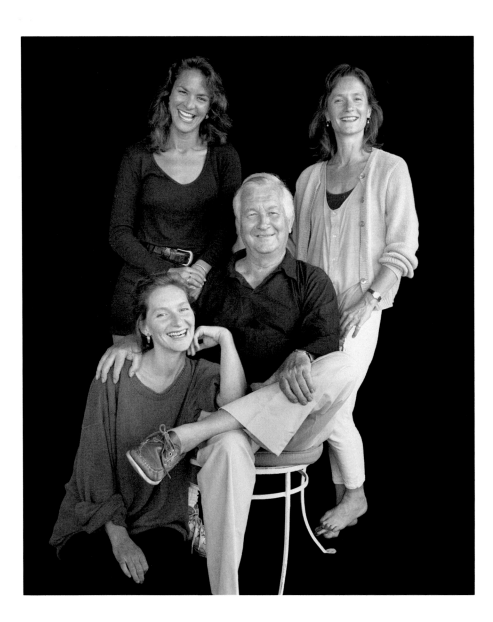

portraits

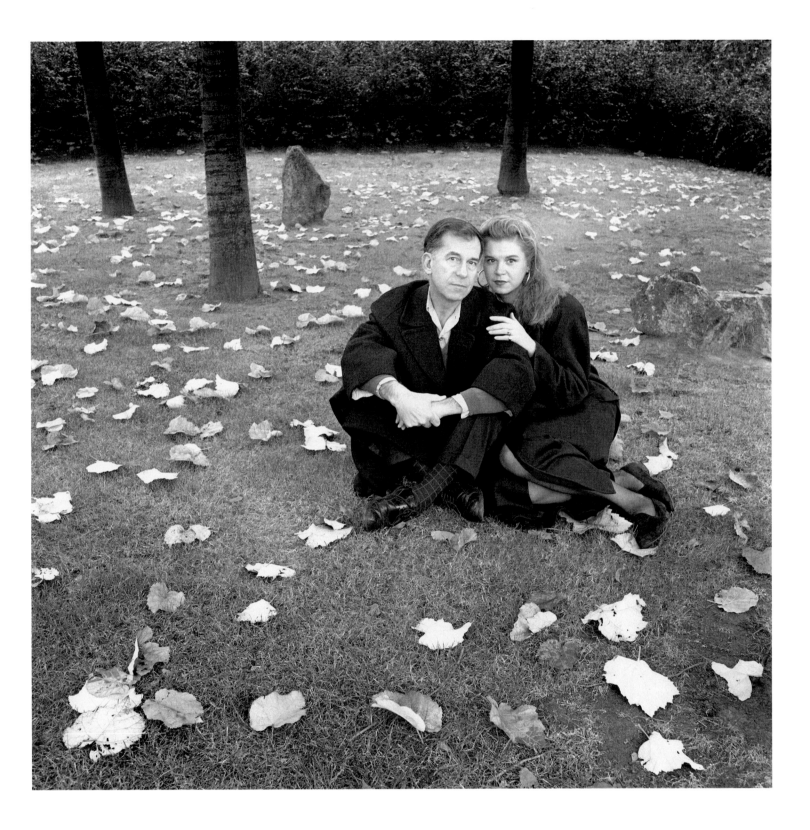

Yvon Lambert and Eve Lavril

Art Dealer / Publicist

Paris, 1992

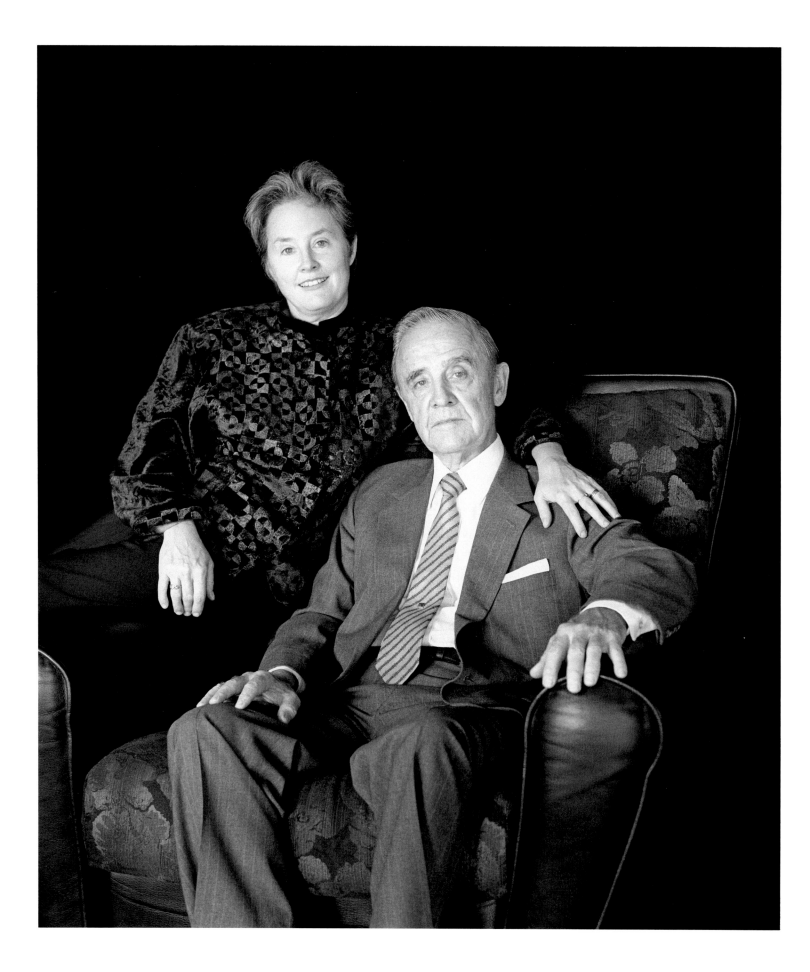

Charles and Alice Waters

Management Consultant / Founder and Owner of Chez Panisse Restaurant
Berkeley, California, 1992

Charles Waters: One evening as I walked in the front door, I heard a heated conversation between my wife and my daughter Alice. My wife was saying, "Hurry up and set the table. Daddy will be home soon!" Alice answered, "I won't. It's not my turn!"

I entered the kitchen and listened for a few moments. Then I suggested that Alice accompany me upstairs to help put my things away and find my lounging jacket and slippers. Without hesitating a second, Alice ran ahead to the bedroom and found my slippers. I complimented her on helping me and once she'd calmed down, I asked, "Why do you refuse to set the table tonight?" Alice responded, "Mommy won't let me have my allowance." I didn't grasp the correlation between Alice's allowance and setting the table, but I continued the discussion. "You always receive your allowance on Friday and this is only Wednesday. Why do you want to have it today?" Alice informed me that her school was having a bazaar on Thursday and she wanted to buy some things. "How would it be," I said, "if I lend you the money now and you can repay me when you receive your allowance on Friday?" Alice was very pleased with this idea. I then asked her what the allowance had to do with setting the table.

"It's not my turn!" Alice repeated. "Let's see," I said, "I remember your sister Ellen set the table on Sunday when we had guests. You must have set it on Monday and Ellen again on Tuesday. Today is Wednesday, so it *must* be your turn." At this point Alice started to cry. She said, "I don't like to set the table because every time I do, Ellen criticizes me."

"Let me see how you set the table," I said to Alice. "We'll pretend this book on the bed is a plate, the small ruler is a fork, the pencil a knife, and the pen a spoon." Brushing away her tears, she quickly placed the utensils as she would on the dinner table. Rather than embarrass Alice with her mistakes, I asked how her set-up would work if she were cutting something. After making several attempts, she placed everything correctly. "How will you remember the right placement?" I asked. After thinking for a moment and glancing at her wrists, her eyes lit up and she said, "I know, Daddy. The fork is on the wristwatch side!" At this point I encouraged her. "How about trying to set the table tonight?"

Zoom! Down the stairs she went. She set the table perfectly and even added flowers from our garden. Just as she finished, her sister Ellen came in, placed her hands on her hips with arms askew and exclaimed: "Mother, did you help Alice set the table again?" My wife answered, "No, Ellen, I didn't. Alice did it all by herself!"

From then on, Alice always enjoyed setting the table. Whenever we had guests or holiday dinners, she would create special decorations. She grew up to become one of the most original and successful restaurateurs in the United States.

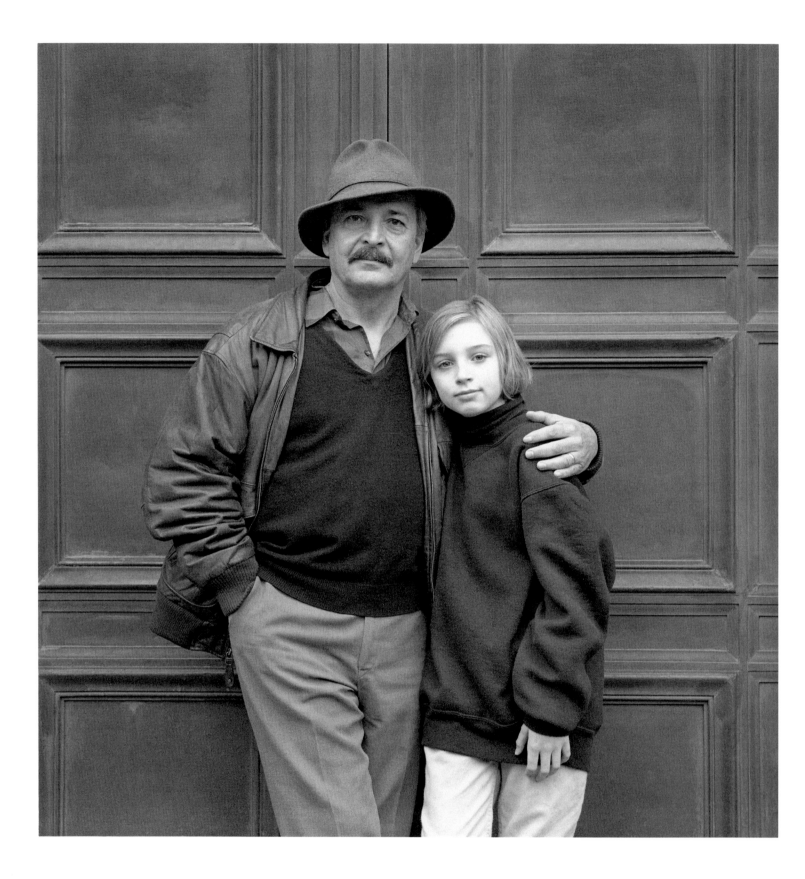

Stratis and Elektra Haviaras

Writer
Cambridge, Massachusetts, 1992

Stratis Haviaras: It was very early one morning in the dead of winter, so to speak, just after the January thaw, that you jumped out of bed as if out of deep water, gasping for oxygen and holding in your fist a half-shell of silverish lining, a remarkable shell shaped like a dove's wing, or like the scirocco unraveling northward, featuring hair-like grooves and other minute indentations and raised pearl around a stream of pin-perforations like astral goosebumps, and it occurred to you then that these represented the recorded sounds of the deep, and that if you could trace grooves and pin-marks with a sharp pencil-point or stylus, out of that shallow hull would flow such subtle sounds and echoes and passing footsteps, a sleeping creature's heart-beat, words whispered in a language lost thousands of years ago, ancient music, or a mindful record of sorrows: exiles, lost lands, age-long yearnings for such lost lands, or joys for that matter in adopted countries, joys gone astray as time wore on; in short, anything perceived once eons ago and still sought after today. And you felt the cold impression of the shell's inner side, its contents already copied into the grooves and patterns of your hand the recipient; and for the first time it occurred to you that the thing to do wouldn't be to transcribe, that is to write everything down on paper, but to retrace the shell's contents, and to speak aloud said testimonies of the sea, said fates, and histories and records of things, whether instructive or useless, right from the shell and the shell's impression into your hand the recipient.

I was still under the spell of this dream while shaving in the morning, when Elektra's alarm clock went off. When she walked into the bathroom she had a mischievous smile on her face. "Look, dad," she said, and opening her fist she showed me a half-shell of silverish lining, that same remarkable shell I had just dreamt about, shaped like a dove's wing and like the scirocco unraveling northward—and I knew that the daughter who'd been born on my own birthday was already claiming what I thought was mine, whether it was hard-earned or given.

As I walked her to school later in the morning, I amused myself wondering what else might be in store for Elektra that day.

Elektra Haviaras: Once there was a storm on our street. The wind was blowing super-fast and hard. It broke a thick branch off one of our trees. My cats were blown all over the place. Then it started to rain. The wind was blowing now harder than before. It was difficult to pick up the cats and even more difficult to get all five of them inside. We locked the door but the wind was rapidly trying to break

the door down. I thought it was exciting but my dad didn't. He thought it would ruin the tomatoes and other vegetables [in the backyard].

Finally the storm stopped and it was morning, but there was no more excitement. I went downstairs to feed the cats. They were soaking wet and had been fighting over the heater. I gave them some cat food and dried them off, one by one. My fat cat named Thuggie was the hardest to dry because she had the most fur. She started to shake the water that had been on her fur onto me. Now I was wet. Thuggie jumped onto the heater which made a loud bang. My gray cat [Meepie] was next in line to be dried off. She was smart and she could do most of it by herself. She started to rub against the towel. Soon she looked all puffed-up as if her fur had been blown by a hair dryer. Then it was my black cat Annie's turn. I started to dry her and she growled at me and so I stopped drying her and she hopped away. But I didn't dare try to dry my red cat named Red. He'd scratch my face.

At ten o'clock it started to get warmer. I went outside to play. Then it was in the 70s, then the 80s, then the 90s. Now my father was worried about the tomatoes burning up.

In the afternoon we drove to the beach.

When I went to bed I wondered what the next day would have in store for me.

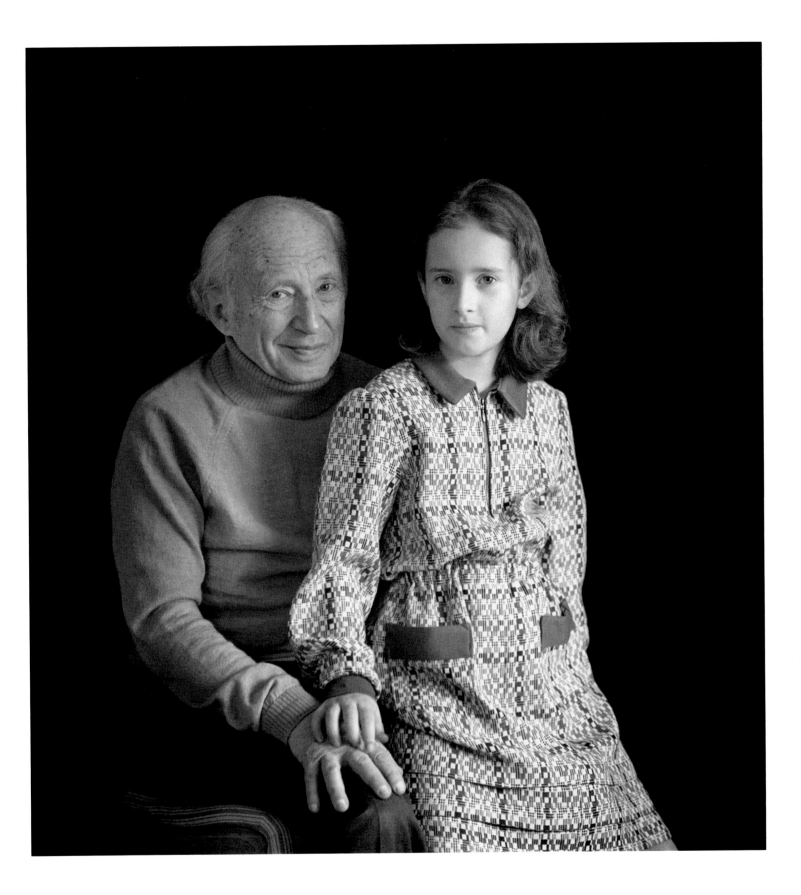

Israel and Tanya Gelfand

Mathematician
Highland Park, New Jersey, 1990

Paul A. Volcker and Janice Zima

Former Chairman of the Federal Reserve Board / Nurse
New York, NY, 1992

*P*aul *A. Volcker:* It's hard for this one father, at least, to put into public words the affection and pride he feels for his own daughter. All I do know is that the older I get, the more I appreciate the qualities of loyalty, of care-giving, of constancy—inside the family first but outside as well—that mark her life.

Maybe that sounds prosaic in a world that puts so much emphasis on individual opportunity, on the glamorous career, and on material luxury. And I wonder, more than once in a while, whether it was fair of me not to encourage much more strongly her remarkable natural artistic talent. The sense of responsibility weighs heavily.

But then, I suspect that the challenge of developing that trio of energetic and strong-willed young sons, frustrating as the process of parenting can sometimes be, balances the scale for her, as their obvious potential shines forth!

What I know for sure is that the love and appreciation of one father for his daughter gets greater and greater as the years go by.

*J*anice *Zima:* Gushy, demonstrative love it is not—I often think it is because of my father's German background. But the feeling of strong love is always there nonetheless, the family commitment to "being there" when it counts.

I often think I have picked up my father's stubbornness, born from the endless family banterings we had at the dinner table—more for the sport of debate than anything else. Rarely did I win an argument, which is probably the reason I don't concede a point easily today.

I remember in particular several points in time with my father. Foremost, I remember breaking up with a boyfriend in high school and being very upset. My father, about to leave on a fishing trip, suggested I miss a few days of school and come with him. He probably wouldn't even remember this but it stands out strongly in my mind as the kind of support and love he gave me. Or the night before my marriage when we walked around the block twenty or so times because of my prenuptial butterflies. I once received a clipped fictional article in the mail from him, about a father who was taking his young daughter fishing (something my own father did frequently) and how their conversation turned to the different types of love that there are. It was his way of saying that to me.

If I convey anything from all this, it is that I am extremely proud to be my father's daughter, and that I have enormous love and respect for him.

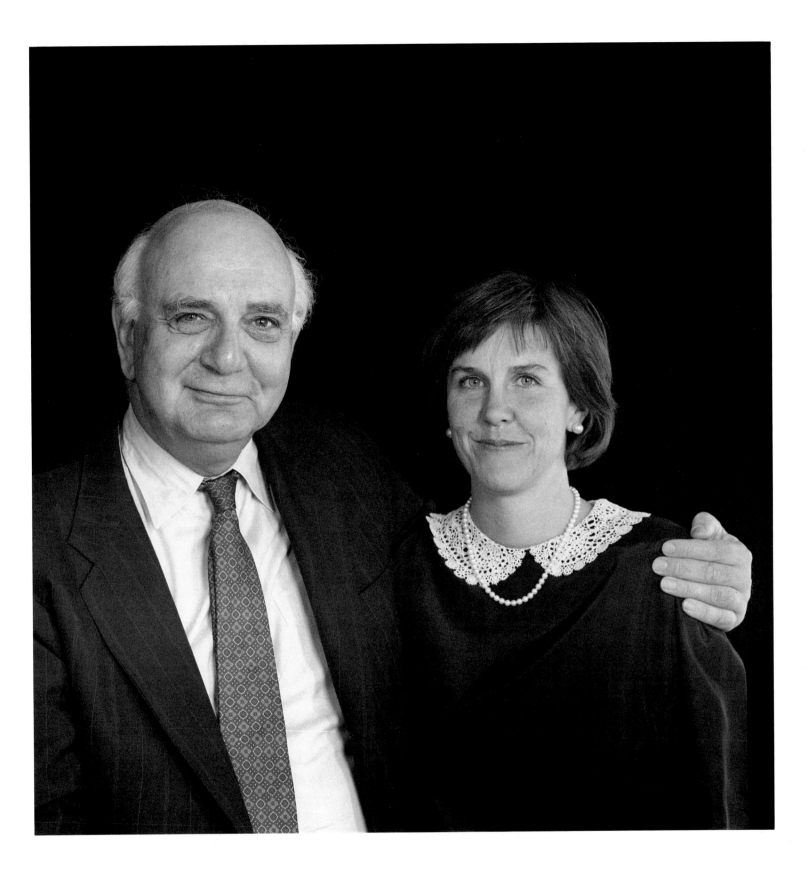

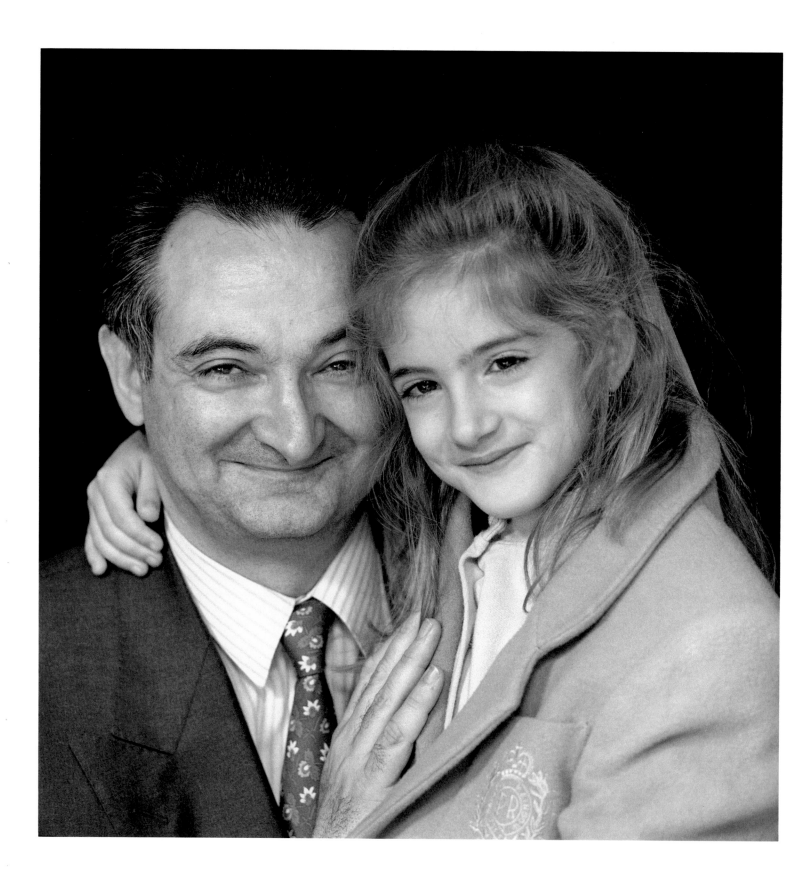

Jacques and Bethsabée Attali

Writer

Paris, 1992

*J*acques *Attali:* Her questions are coming from the end of the ages. Her silences are the slow heritage of uncertain milleniums. Her words are whispered as if she knew for a very short time all that—too soon—life will make her forget. Her answers, coming from the distant future, help me to understand what I desperately try to grasp from a flying past.

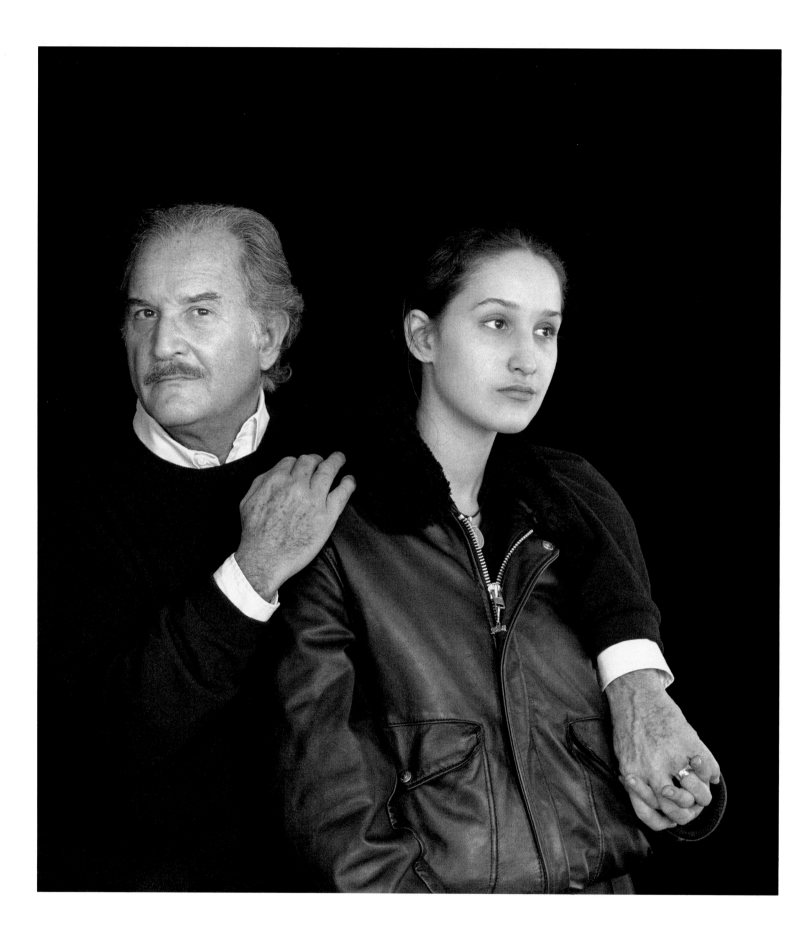

Carlos and Natasha Fuentes

Writer

New York City, 1992

*C*arlos *Fuentes:* Natasha was a bouncy, cheerful child full of fun and imagination. A father's great illusion is that his daughter will always remain so; a source of infinite tenderness and unexpected surprises. The surprises do follow, but they are not always tender or funny. A person cannot enter and leave your living room forever doing cartwheels. First Communion is not an eternal event. Photographs fade, gauze gets torn, silk yellows. . . . I always laugh remembering that Natasha gave me a first intimation of mortality. She was four and skipped with another child through my study, where I was watching television. "Melanie," she said, "this is my father. He is a hundred years old." In this photograph, we are both aging, in different ways, at different paces. There is a struggle here between separation and reunion; the photograph catches this dramatically. I am so sorry that at age eleven Natasha left for boarding school in France and was never my little child again. She cried for a return to the security of what she called "my beautiful house." Discipline, culture, learning languages: the reasons prevailed over the emotions. She was gone. No guilty parties. Nothing but the unending dream of coming to terms with one's own self, with one's parents, with one's children. I am both far and near to her in this photo; so is she from herself. She is seen at a final, painful moment of adolescence, no longer confident, no longer at ease with herself or with me. She called it her "young grim winter," finding ways to invent and re-invent herself over and over again, to please, to shock. Loud and silly sometimes, smooth and cool at others, reading like a famished outcast who finds a caseful of books on an island, surprising her teachers, correcting them, having read through the complete works of Artaud at age fourteen, about to become the child in the *New Yorker* cartoon whose teacher, gun in hand, starkly states: "You know too much." She knew too much, shielded herself in knowledge both brilliant and evil, did not find the way to invent herself on a stage, on a piece of paper, instead acting out the night, writing on the pavement. In this photo, she is about to go from being in the open or being in seclusion, to being with others, acting, writing, finding out *where* being absolute is a virtue. She does not cling to me. I cling to her. She has always occupied my dreams. But now she has become so beautiful that she also occupies my imagination and my next novel, *La Novia Muerta*, is dedicated to her, to her enigma.

General Colin L. Powell, Linda, and Annemarie Powell

Chairman of the Joint Chiefs of Staff / Actress / Television News Production Assistant
Washington, D.C., 1992

*C*olin *Powell:* When the photograph arrived, Linda and Anne immediately began to critique their appearance: wrong pose, wrong clothes. I escaped the usual snickering.

I couldn't take my eyes off the photograph. My daughters looked so beautiful. Looking at the picture, my thoughts went back to the day each of them was born and my heart quickened as it did when I saw them for the first time. They were beautiful then. Over the years, day by day, they have grown more beautiful and have brought me nothing but joy and pride. They own my heart.

*L*inda *Powell:* My father is a gentle man, but, as a child, I remember being a little afraid of him—he was so big. He rarely raised his voice, but when he did, my heart would drop through my stomach. But I also remember once weaving pink and white net around my bicycle as decoration so that as I picked up speed it would trail color behind me. The net got caught in the spokes and I went flying over the front of the handlebars. I sat stunned and crying on the asphalt. My father appeared from nowhere, scooped me up, held me close, and carried me home.

*A*nnemarie *Powell:*

Dad is the smartest person I have ever known.

He always wins at Trivial Pursuit.

He's always been frank with me when it was necessary.

He looks great in a tux or his dress blues.

His successes never surprise me; they just make me proud.

He's the best mechanic in town.

I have always had the secure feeling that he could and would take care of us, no matter what.

And he gives a great hug.

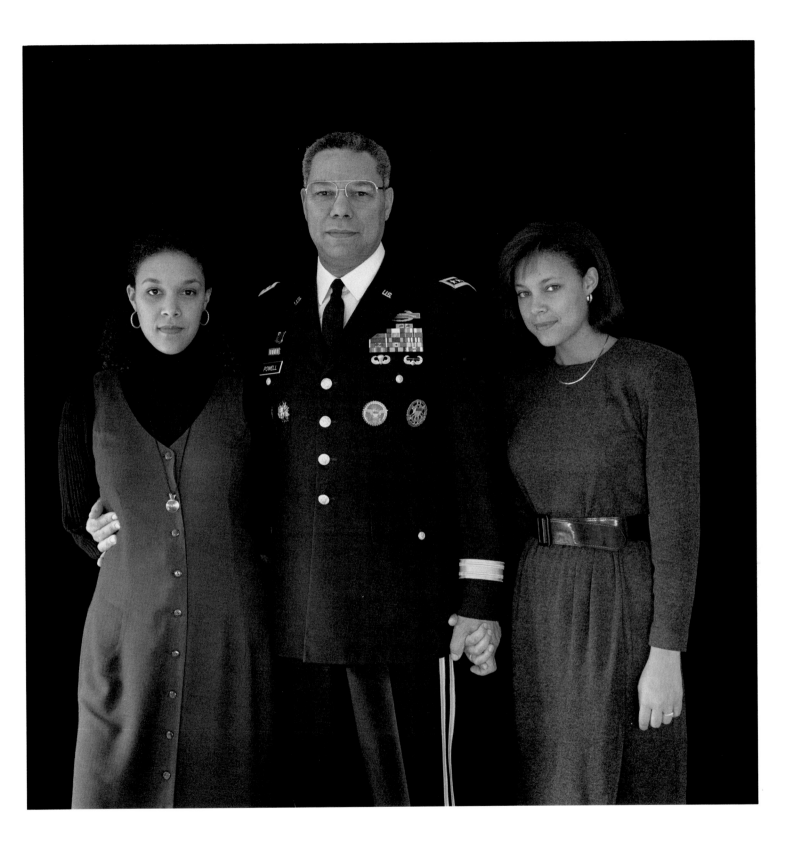

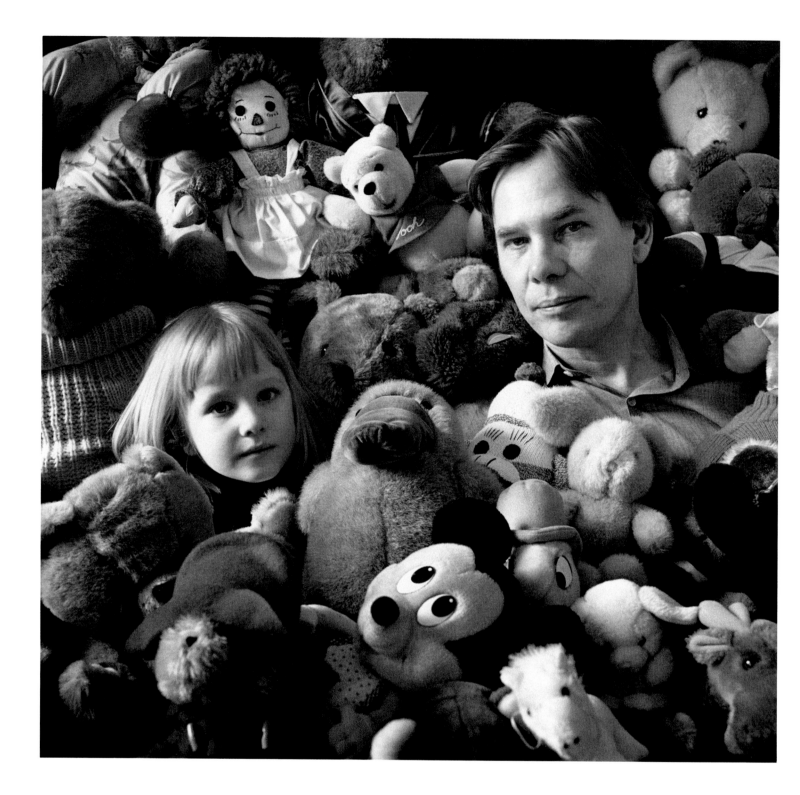

Billy and Caroline Copley

Painter
New York City, 1992

*B*illy Copley: One thing I'll say about Caroline is that she always puts her best foot forward. No matter what the situation, she is always ready to go and have fun. I was never like that as a kid so I am in awe of her self-confidence and positive outlook.

She likes to change clothes a lot and has always got a pile of extra stuff to take along even if we are only going to the market. It is also easy to hurt her feelings so I've learned to be more patient with her. She is great fun to be with and we do a lot of things together.

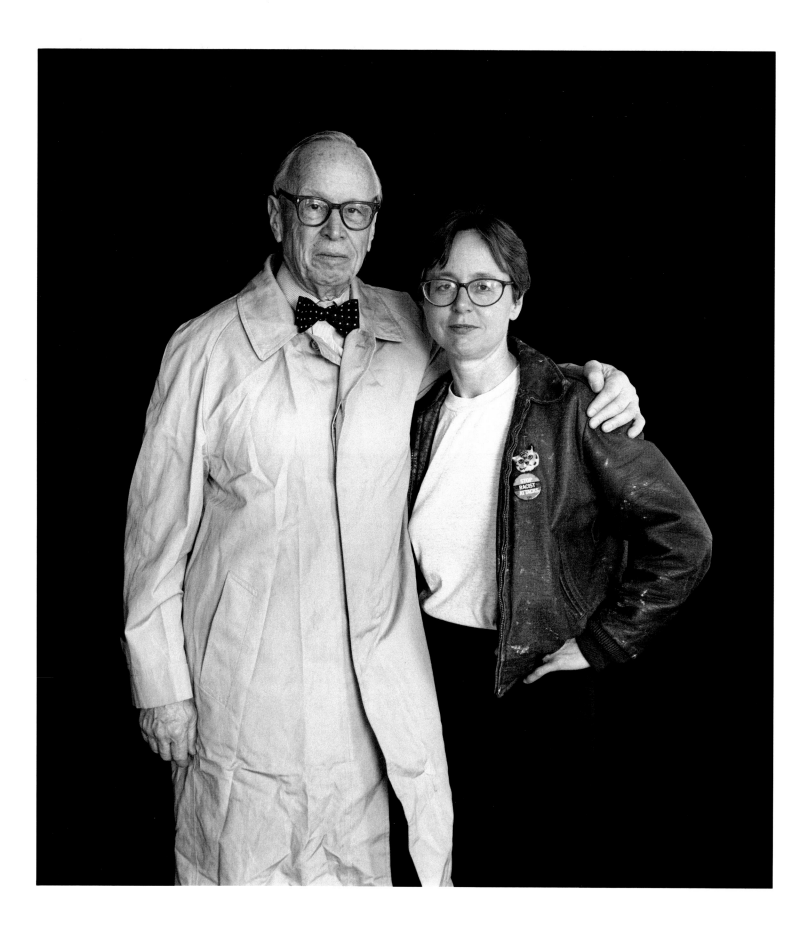

Arthur Schlesinger, Jr., and Christina Schlesinger

Historian / Painter
New York City, 1992

Arthur Schlesinger, Jr.: My daughter Christina was a free spirit from birth. She burst into life sparkling with curiosity and pride and joy. Even as a little girl, she was determined to assert her rights, find out something about everything and live life to the hilt. Early on she developed a strong if sometimes tremulous sense of identity, and developed too a marked talent for writing and for drawing.

After Medeira and Radcliffe, she plunged into the excitements of the 1960s. An experimenter by temperament, Christina tried many things, including, to the dismay of her parents, parachute-jumping. Painting, it soon became clear, was her destiny. Critics praise the dreamlike power of her haunting pictures of trees and fish and waterfalls. Her vivid murals in Los Angeles, Kansas City, the South Bronx and New Hampshire glow with imagination and wonder.

She also teaches art at inner-city public schools in Harlem and the South Bronx. Christina is a natural teacher, and a brave one too. I worry when she goes off on her teaching expeditions, but I love watching her win over shy and mistrustful children, imbue them with confidence and enthusiasm and organize them to adorn gloomy schools with bright artwork.

Christina is a gallant young woman of independence and of courage. She is dedicated to her art, caring of her students, a battler for her sex. With unquenchable charm and humor, she never lets her father get away with anything—which is why I have been one of her most grateful pupils. She remains always the greatest fun.

Christina Schlesinger: My father's self-confidence and powers of concentration have always impressed me. When we kids were little, he wrote his books with all of us screaming around him. I used to play in the wastebasket while he typed. I've always tried to identify with his self-confidence and drive.

I am an artist, and he is very supportive. Whenever I have an interest or travel somewhere new, he floods me with clippings and books: on Australia, on China, on feminism. He always comes to my openings and mural dedications even when they are way out in the South Bronx, the East Village—even Kansas City. I can count on him being there with his bowtie.

Recently I've been painting murals as well as doing my own work. Mural-making combines history with art, and my father seems to especially enjoy them. I'll never forget the excitement in his voice when he phoned me from the Greyhound Terminal in downtown Los Angeles after seeing my murals there.

I am very proud of my father. I feel he gave me excellent values. He's always encouraged me to work hard and be professional and play hard and have fun. He's taught me to be true to myself, quoting Emerson and Thoreau to me, even when he's been uncomfortable with the results. It's nice to have a father with whom you agree on most things and if you don't, he welcomes a good argument. Ever since I was little, we've had fun arguing. Not that he always comes around, but he listens. He still needs some help on some things. Such as I know he's a feminist, but deep down I think he's old-fashioned about women.

He's given me a passion for the ocean, travel, and books. He's given me the best gift of all: not to be afraid of life.

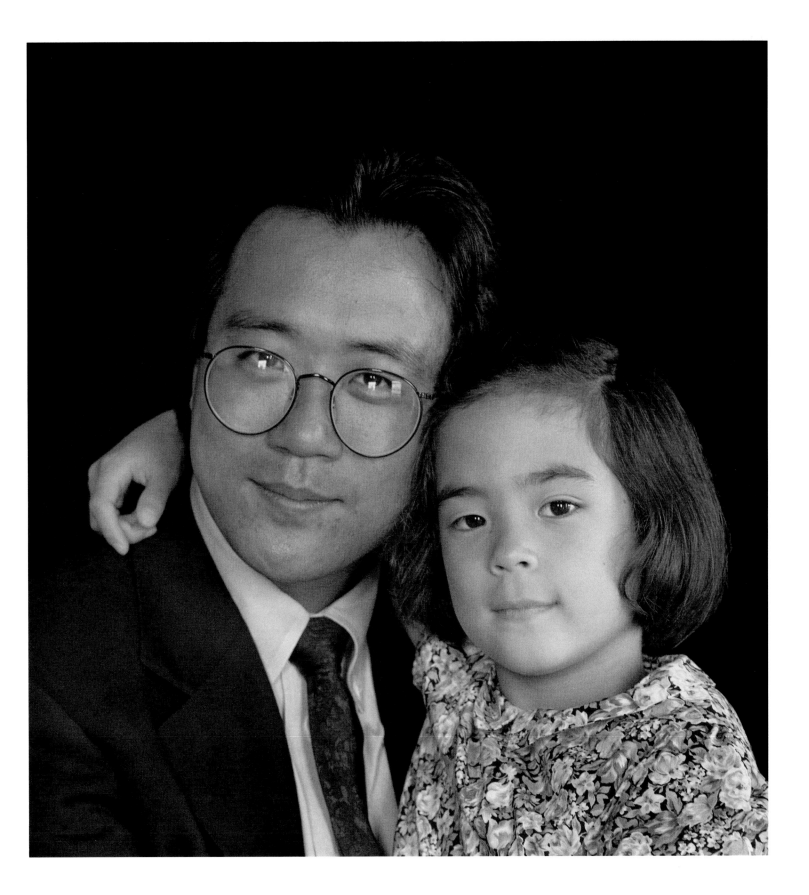

Yo Yo and Emily Ma

Cellist
Tanglewood, Massachusetts, 1992

André and Isabelle Jammes

Booksellers
Paris, 1991

*A*ndré *Jammes:* Posing for a photographer is very upsetting. The camera seizes an image which we have reason to fear is an accurate one. Balzac thought he lost part of himself every time he posed for a daguerreotype. We have to find excuses to have our picture taken and in my case the most seductive is to pose with Isabelle.

*I*sabelle *Jammes:* Here we are, both of us booksellers in the family bookshop begun by my grandfather sixty-seven years ago. It is the same room where my mother gave birth to me and where working lives spin themselves out in the medieval tradition, the symbol of long and peaceful happiness.

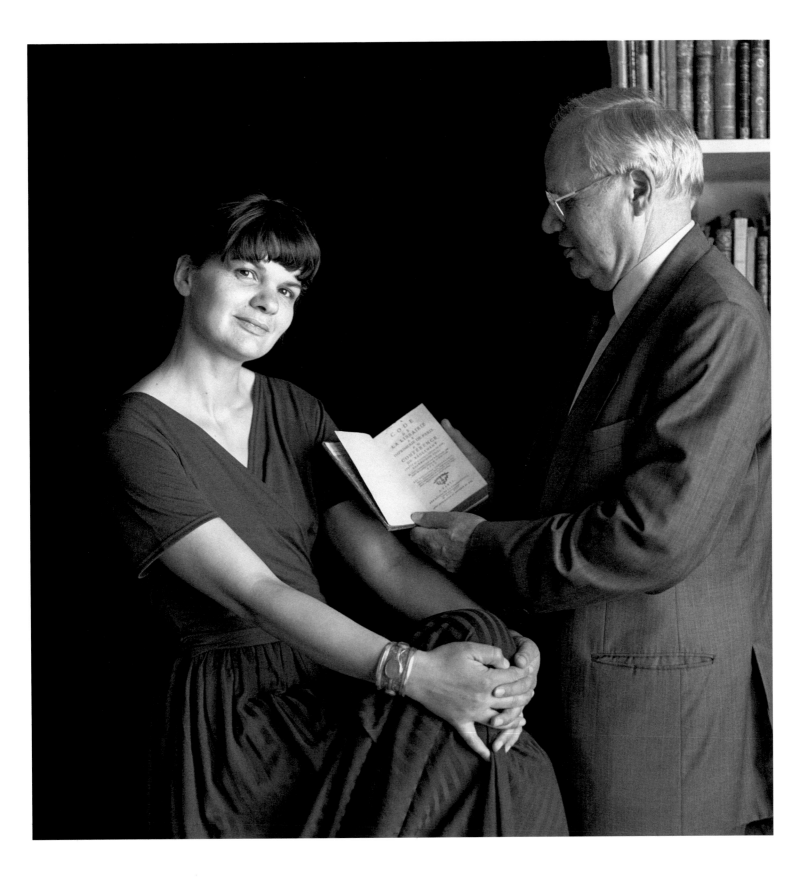

Mark and Madeline Bromley

Biology Teacher
Salt Lake City, Utah, 1992

*M*ark Bromley: Madeline's tenderness was exposed last winter after she suffered a head trauma that required hospitalization. Her first groggy words to me were, "I'm sorry I ruined the family vacation. I hope that this doesn't cost too much." My affection for her is also deepened by the fact that she is our youngest child, and by knowing how quickly time passes.

When I see Madeline at school she frequently breaks ranks and races down the hall to give me a hug. She loves to play charades: it is a point of pride with her to act out the most obscure titles. We both love to listen to lively music and I admire her whiny Randy Travis voice-overs.

When Made was little, her notion of utopia was owning "seventy horses mostly white." For now she settles for equine pictures. She makes memorable chocolate chip cookies, with so many chips that there is barely enough flour matrix to hold them together. She is at her happiest when cutting and arranging fresh flowers and making sure that I notice and comment on them.

*M*adeline Bromley: My dad made a deal with me. He said if I learned the names of twenty kinds of horses, he would take me horseback riding. And he did, even though he hates horses.

My dad is a plain dad. He comes home every night and eats dinner with us. He plays board games with me. He also takes me on trips.

No matter what he's talking about, he can always make someone laugh because he is very funny.

Our relationship has been short but is still growing.

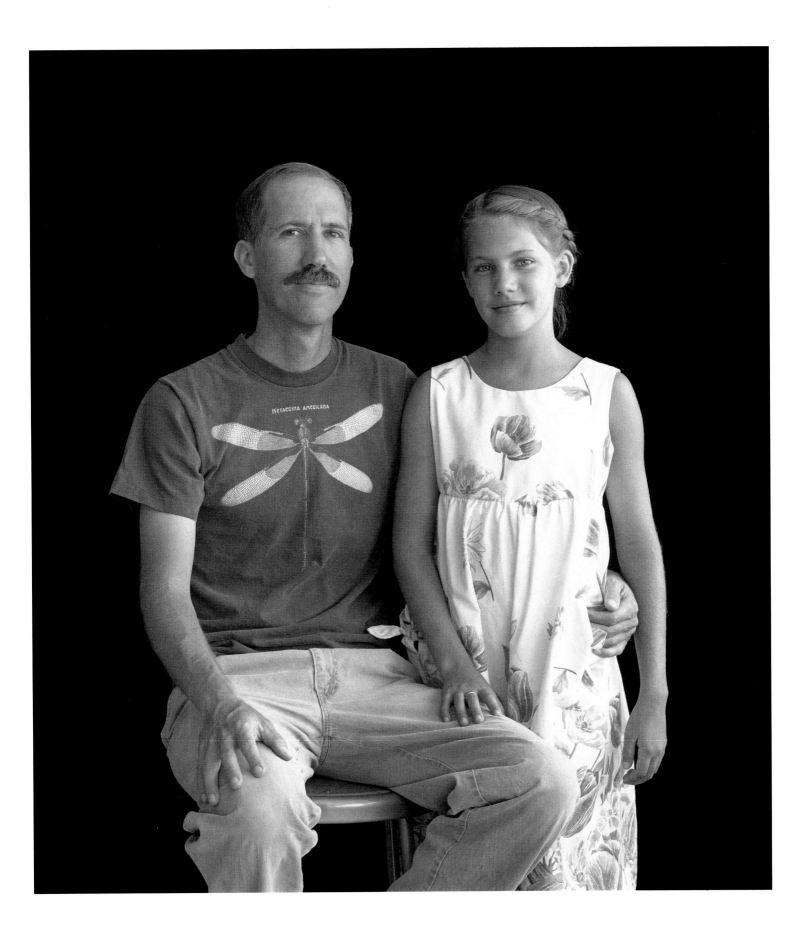

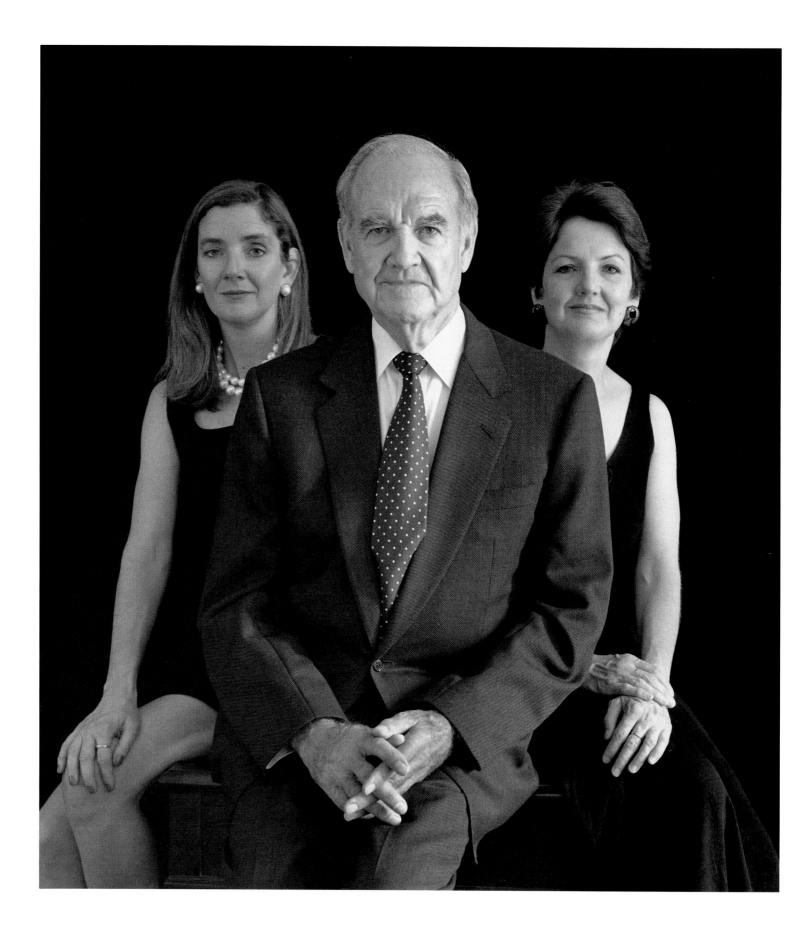

Senator George McGovern, Mary, and Susan McGovern

Former United States Senator /
United Nations Management Official / International Relations Specialist
New York City, 1992

George McGovern: It has never been easy for me to write about my feelings for my children. It hasn't even been easy to tell them directly of my most personal feelings about them. Why is this? Perhaps because for most of their lives my love for them has seldom been matched by a commensurate investment of time, attention, listening, nurturing, counseling and direct involvement.

It is somewhat painful—and perhaps slightly hypocritical—to tell a child of your love when in fact your life is directed from early morning to late into the night by political ambition, public service, and national and international affairs, to say nothing of one's personal involvements outside the family. A public man tends to be caught up in the needs of the universal child (and adult) while sometimes ignoring the most pressing and poignant needs of his own child. Even one's own soul may be diminished in the distractions and demands of the political whirl.

A few years ago at a large dinner party for his aging father, a prominent Washington publisher stood with his hand on his father's shoulder to offer a toast. "I want to say some things tonight about my feelings for my father that I can't possibly tell him in private," he said. I identify with that paradoxical confession.

In that spirit, perhaps I can use this public page to express a few words about my children that I can't come right out with in private. Sue and Mary are with me in this photograph because they happened to be in New York when it was taken, but what I have to say here belongs equally to Ann, Teresa, and Steve.

The simplest and most important public confession about my five children is that I love them. I love them in a special way because of our shared history—the births, the countless delights of early childhood; the fun, kidding, horseplay, laughter and tears at home; the meals and conversations, the picnics and trips, the struggles of growing up, the Christmas and Thanksgiving dinners, the schools and teachers, the anxieties and heartache of the drug culture and the sexual revolution, the joy and the problems of their love affairs and their families.

I love them because of their sharing in my public life, including public appearances they would rather have avoided and a searing public spotlight they would have sometimes preferred not to share. They experienced the agony of seeing and hearing their father misjudged and rejected as well as the ecstasy and satisfaction of elections won and causes triumphant!

I love them because they are free of bigotry, self-righteousness, arrogance and narrowness. They are human beings guided by idealism, compassion, a sense of justice and a social conscience. Perhaps Eleanor and I can claim some credit for these values that we admire and treasure in all of them.

I love them because each of them has a unique sense of humor, an engaging wit, and an appreciation for irony.

41

I love them finally because, despite my shortcomings as a father, I believe that they love me and admire me. Indeed, just as I love them more consciously today than I may have ten, twenty, or thirty years ago, so it seems to me that they love me more than ever. Isn't that fortunate—to be moving in a happy direction for the future, sharpened by countless memories of good times and bad that give meaning and resolution to our lives.

Mary McGovern: I distinctly remember watching on the television set in the kitchen Air Force One delivering the body of President Kennedy. I turned to ask my Dad a question and saw silent tears rolling down his cheeks. It unnerved me terribly that something could make my Dad cry.

I didn't see him very often when I was growing up, and I was very shy around my Dad. It seemed in my family that there was room for only one star, and that was he. Consequently, as a rebellious teenager, I felt I had been neglected by him, that he was to blame for my personal problems. I did not, in my secret heart, believe that he loved me.

It was as an adult that I found my father. In the aftermath of the 1972 campaign, I saw the profundity of his hurt and sadness and understood for the first time that my Dad was a human being like anyone else. I felt free for the first time to admire him, to admire his character. Eventually, I ceased to blame him for whatever problems I had. I knew that with a different upbringing, some things in life would have been easier for me to manage. Still, I could manage, in spite of the difficulties. I understood that I was responsible for creating my own happiness.

I remember quite distinctly the moment I ceased to be afraid of him. That changed everything. I could speak to him honestly; I could tell him what I really thought instead of saying what I thought he wanted to hear. I realized that, somewhere along the way, he had passed on to me his passion for justice, for what was right. He has also passed on to me his idealism, his commitment, his capacity for hard work, his enthusiasm, his optimism.

I have had a life filled with many blessings, and I am grateful for each and every one of them. One of those blessings is that I have a father who I am close to, who was after all a good role model, an inspiration really. It is gratifying to know that I love my father, and that he loves me.

It is also gratifying to know that in addition to loving him, I really like him. He is a good, decent man who has poured his energies into worthwhile work and has tolerated a great deal of public abuse with good grace. He is kind, generous and extremely funny. I think my Dad has been made the object of derision because people resent someone who has retained the idealism and dreams of his youth when so many others have long since abandoned theirs. I admire him for taking this abuse, and for never, ever giving up the fight.

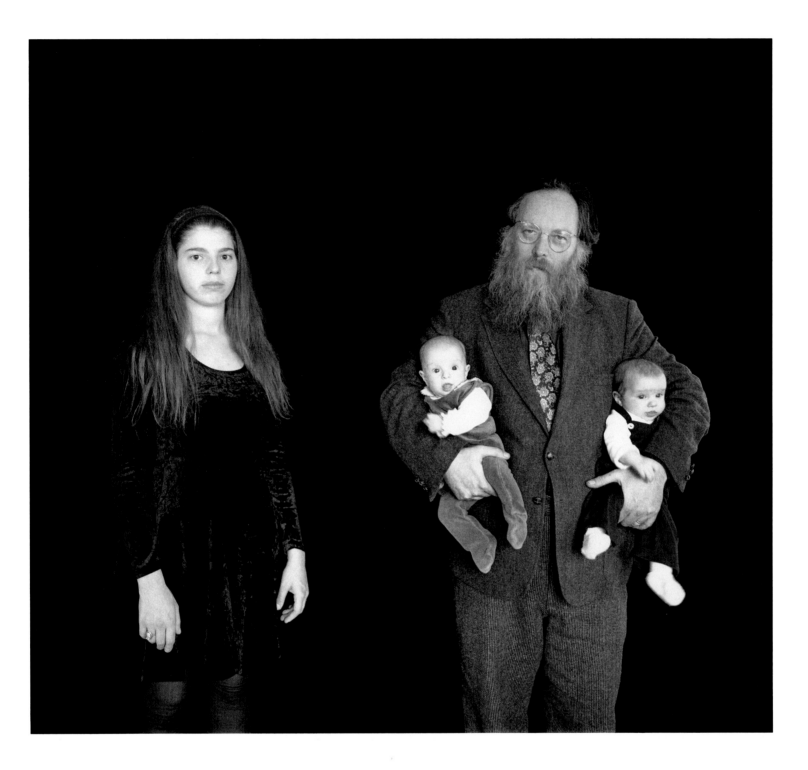

P. Adams, Sky, Miranda, and Augusta Sitney

Professor of Film
New York City, 1990

Joshua and Stella Baer

Dealer in American Indian Art
Santa Fe, New Mexico, 1991

Joshua Baer: Stella was born in 1981. From the beginning, she always made me feel safe and protected. This struck me as odd because, as her father, I assumed it was my role to protect her.

In February of 1989, Stella came to my gallery one morning and got into a friendly conversation with my secretary, who was doing paperwork in her office. In the middle of their conversation, an ex-boyfriend of my secretary walked into her office and asked for a cup of coffee. My secretary told him that we didn't have any coffee, but would he like tea? At that point, Stella got up and started to walk out of my secretary's office. The ex-boyfriend said, "Come back in here, honey," but Stella ignored him and walked out into the gallery, where she found me. She had a strange look on her face and I was about to ask her what was wrong when I heard three loud popping noises from my secretary's office.

I looked at Stella's face and said, "Let's go." She turned and ran out of the gallery. I was right behind her. We ran across the street and into a poster shop. I took Stella into the back of the shop and locked her in their storage room. Then I called 911. After the police arrived, I learned that my secretary had been shot five times, was dead, and that her ex-boyfriend had shot himself twice in the head. He died that evening. Later, the police revealed that he had been carrying five pistols on his body, and more than one thousand rounds of ammunition.

In the days that followed the shooting, I told Stella that she had saved my life. I told her that if she had not been there that morning, I would have heard the shots, run into my secretary's office and been killed. To this day, I remain convinced—and very grateful—that Stella saved my life.

Stella Baer: My dad is a very sensitive and generous person. He would do almost anything for me and he's very understanding. I think most parents love their children but sometimes they wish they never had them. I know my dad would never even think of wishing that. He really loves me.

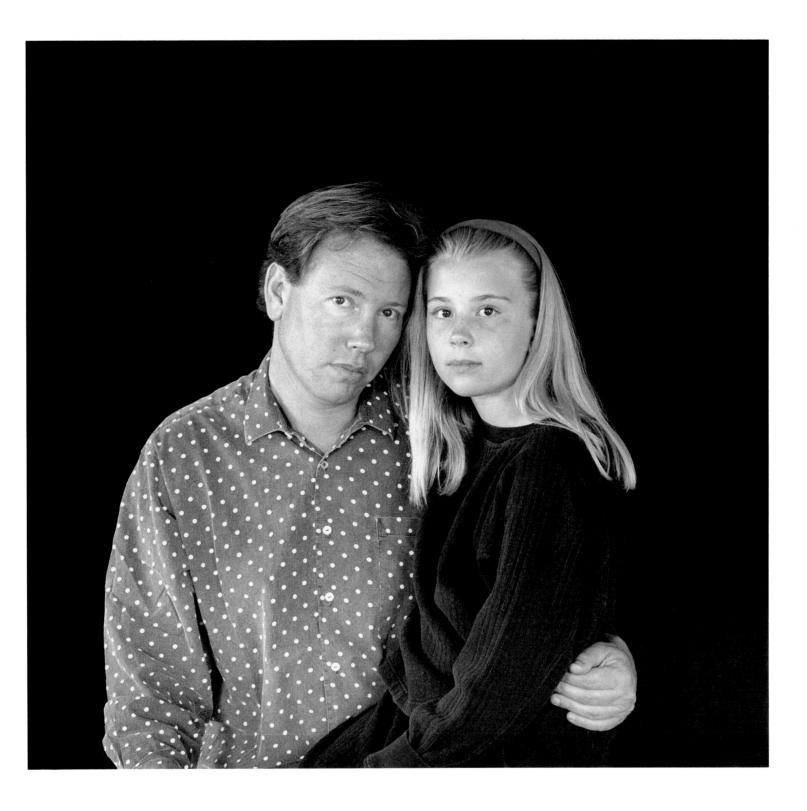

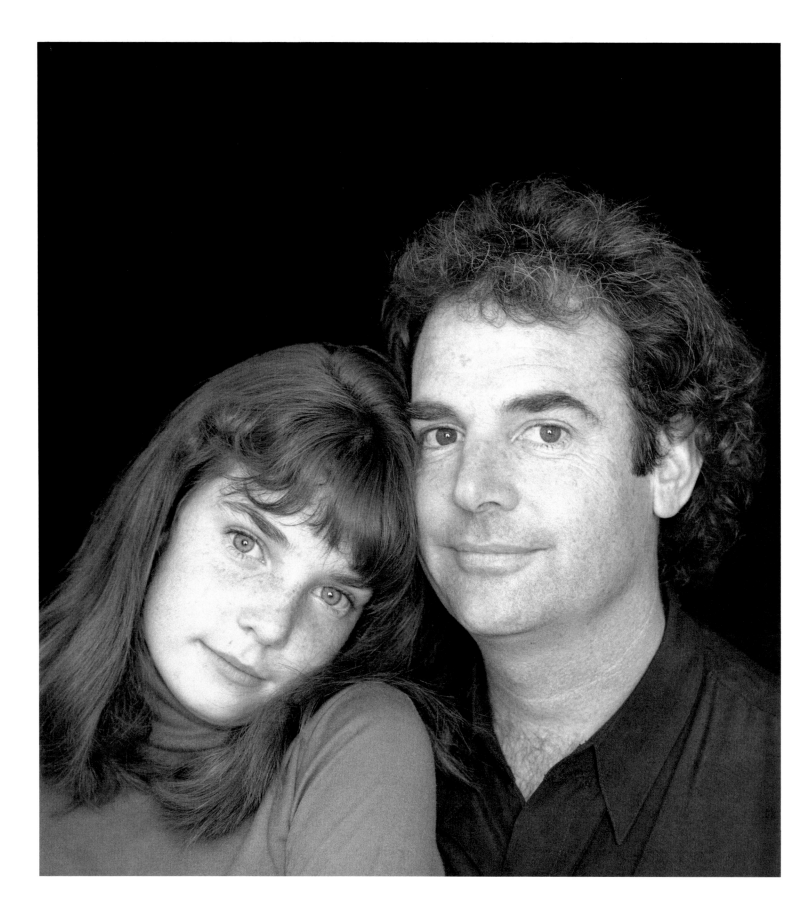

David and Challee Ankrum

Actor, Writer
Los Angeles, 1991

*D*avid Ankrum: When Challee was born, fresh from the womb, she opened her eyes wide and stared at me. She was the most beautiful creature I had ever seen. I was so proud. I called my mother from the hospital pay phone to tell her the news. Overcome with emotion, I could barely speak. "It's a . . . gaa . . . it's a . . . gaa . . . ga . . . ggirrl!!"

They say that the eyes are the windows to the soul. Challee's soul is bright and full of mystery and wonder. We have a timeless connection.

When I hit an emotional and spiritual bottom and my demons took hold of my heart, it was the thought of losing Challee that gave me strength to seek help and to begin to grow. We're growing up together. I thank God for putting Challee in my life.

*C*hallee Ankrum: I think I have the most caring father in the world. My father loves me and I'm glad that I'm fortunate enough to have a nice dad. He helps me with my homework and lots of other things. We have fun together. He makes me laugh. Sometimes we go to amusement parks. We like going on the fast rides together. I love my dad a lot. There is no other dad like him.

Judge William Steele Sessions and Sara Sessions

Director of the F.B.I. / Dancer
Washington, D.C., 1992

William S. Sessions: She looked me straight in the eye and said "no." Three years old, tall for her age and intent on the book in front of her. "Sara," I said, "Come to supper. We are ready to say 'Grace.'" She looked up. "No," she said again, evenly. As father of three teenage boys who were sitting patiently at the table, I felt an example had to be made with my late-in-life daughter, the joyous bloom on my fatherhood. I picked her up and applied a chastising hand. For two weeks she avoided me, not speaking except to say once, "You hurt me." It was a lesson learned between two tough-minded and independent people who have over the years respected and loved the integrity of individualism and sacredness of personality. She has needed self-discipline, quiet assertiveness and self-control to achieve professional status in her chosen art. And so have I.

Sara Sessions: At last summer vacation had arrived, with its lazy afternoons and endless hours to be whiled away in the cool, whispering waters of their beloved river. City clothes cast aside and threadbare swimming suits donned, father and daughter slipped into the water and sighed as their feet sank into the familiar mire of the river bed. Taking hands to steady each other as they waded through the waist-deep (chest-deep on her ten-year-old body) waters, they began the annual migration to the mecca of spring-fed watering holes at the river's source. Their eyes danced with anticipation of the sublime, even as the gentle waves washed away their earthly cares. Paradise awaited.

Paradise, however, was not to be gained by faith alone. The waters shallowed around the tide pools and to their dismay, they discovered their pool filled with stones and enshrouded by silt from the previous winter's storms. Relaxation dissipated as determination came rushing back to set their hands to the task of clearing the waters. Side by side, they worked until her tender fingertips became blood-stained. Cradling her wounds in the shelter of his fatherly palm, he raised her fingers to his lips for a soothing kiss. "A day's work comes with a little bit of pain," he reminded her. "And a little bit of pain is good for everybody," they repeated together.

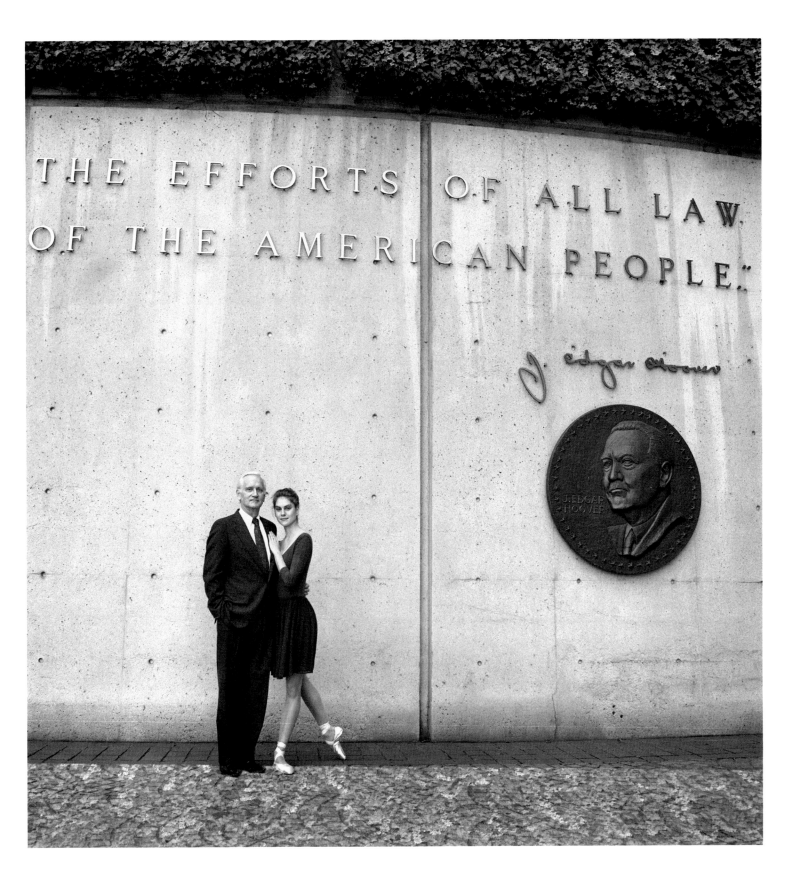

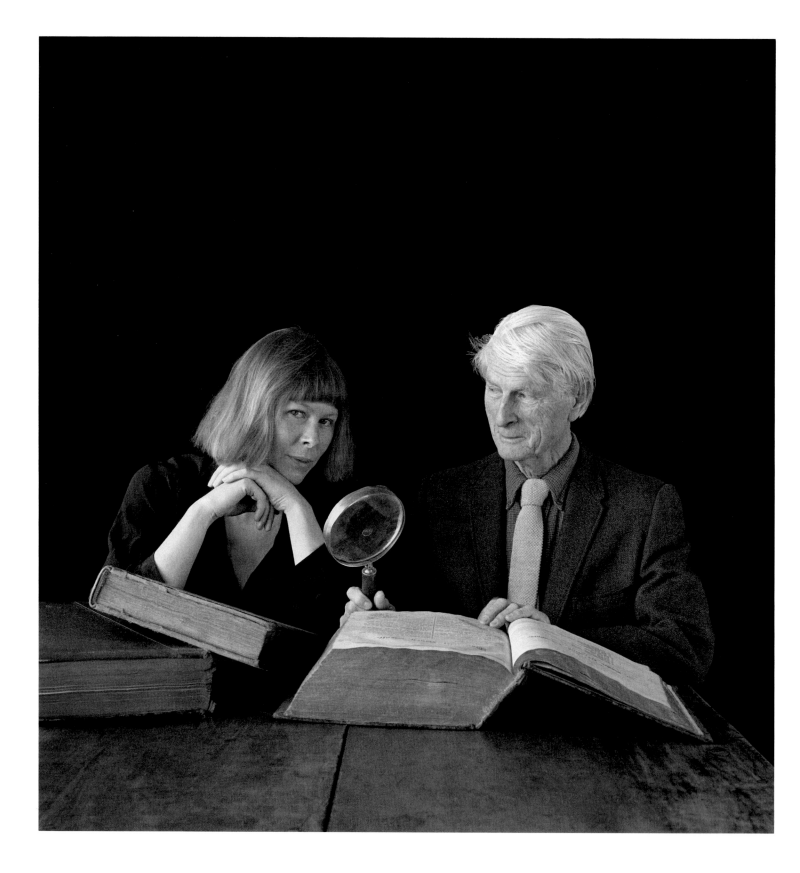

Charles and Carola Bell

Tutor Emeritus, St. John's College, Writer / Writer
Santa Fe, New Mexico, 1991

Charles Bell: Should I account for the loving tension and irony of this double portrait? I, having piled up those huge German Bibles, as if to taunt dear Carola for a life of somewhat capricious defiance of what schools and society asked of her? I, sympathizing with such revolt—having followed it myself in a way, but never, alas, without doing my homework and securing my support. Yet surely, I would not have so backed her life (even by work and sacrifice, supplying needs her negligence occasioned) had I not fondly admired her rebel creativity. All of which, it seems, is caught in this telling picture.

Carola Bell: The erudite scholar with his old German texts has never stopped hoping that his daughter will finally embrace the printed page. But she looks off, more intent to discover the print of sands, cloud whirls, laughter and shifting metaphor. Of course, he, the father, also taught her this and it would be unfair to say that he is academic and she nascent and fluidic. For he is one and she many and likewise and reversed. But German—Gruss Gott! Can't we communicate in a language that we both love and know?

The Very Reverend James Parks Morton and Sophia Morton

Dean of the Cathedral of St. John the Divine / Actress
New York City, 1992

*J*im Morton: Jim Morton: architect, activist, priest, environmentalist, outgoing enthusiast, married for thirty-nine years, father of four daughters and grandfather of five (three grandsons; two granddaughters).

I am the master, slave, lover, and combatant of a great Cathedral, a consuming mistress about whom the five women of my life are also my honest consultants, even if they say I don't listen. Sophia, whom fate and schedule permitted to share with me this photograph, is an actress, outgoing, passionate, a woman sincerely interested and involved in her world. Nine-month-old Sophia and I took daily expeditions to the Luxembourg while I was on sabbatical in Paris. Later, in college, she traveled with me to meetings in India, London, Jerusalem, and Japan. As a small child Sophia asked immense questions: Where did God and bread come from? Each of our daughters is a fabulously creative and uniquely beautiful universe whom I admire and love.

*S*ophia Morton: I believe there exists an unspoken language between fathers and daughters, so it's hard to find the words to describe the special relationship I have with mine. He is a father to four women and one massive, ever-changing, wild Cathedral. The Very Daddy (as I've always called him) is a complex, creative man, filled with passion, enthusiasm and determination. His life is devoted to the vision he has for the Cathedral, the Community, the Environment and the World. He has always allowed and encouraged me to dream big dreams, and that's very important! I used to want to be a priest. In kindergarten, I held confessions in my cubbyhole. A few years later I decided to do the next best thing. Now I'm an actress. His stage is the Cathedral. I'm still looking for mine!

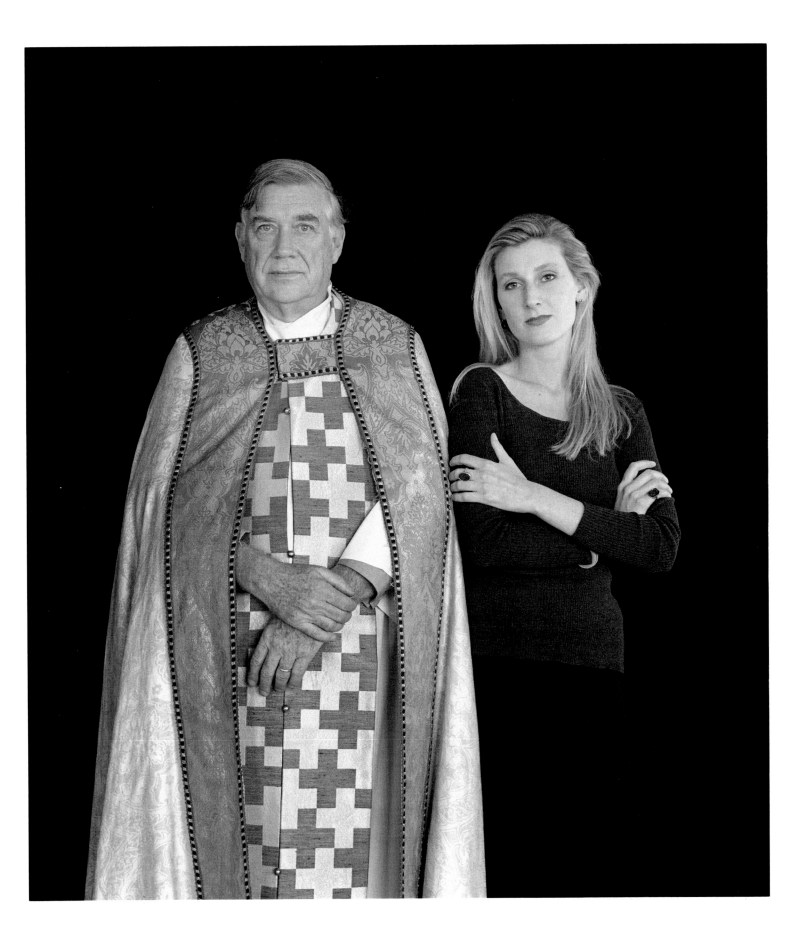

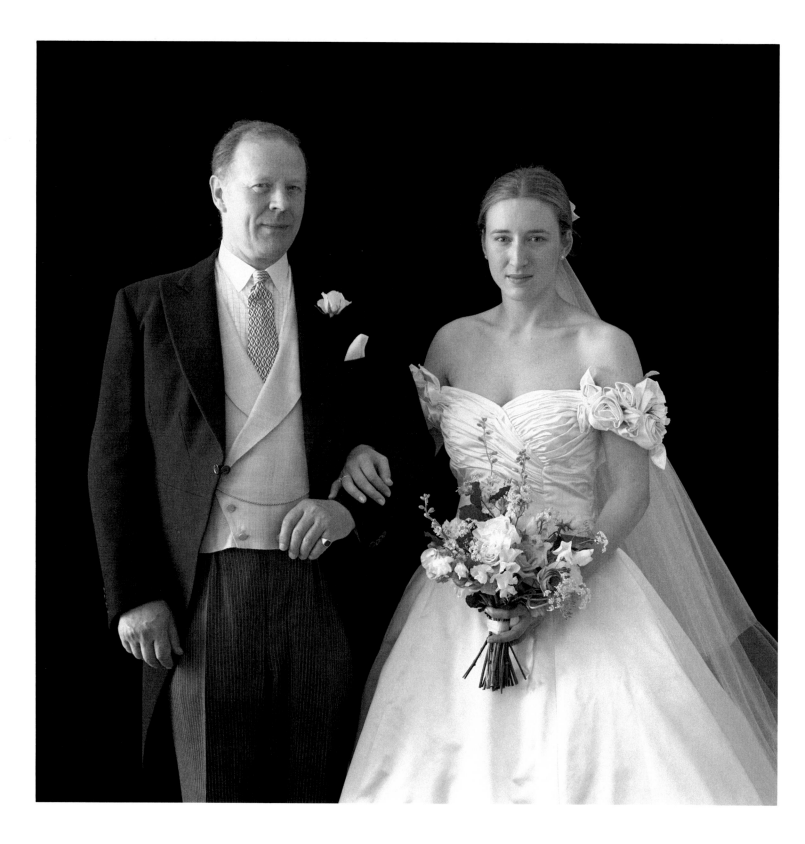

Gareth and Arabella Lewis

CEO, Berkeley Insurance Limited / Clothing Designer
Newton Valence, Hampshire, England, 1993

Gareth Lewis: A wedding has its serious side: "Who giveth this woman to this man?" I don't even get to say "I do"; I just pass her hand over to the Vicar and he passes it on to the bridegroom. My eldest daughter becomes the responsibility of someone else, but even more important, implied but not stated, she becomes responsible for a husband and begins a totally different relationship with us, one that is now secondary to her marriage. How have we equipped her for this task? I believe pretty well, and I am confident that we are passing over a mature, independent person who some time ago fled the nest and discarded the petty discipline and restrictions of parental guidance. At the same time, she has retained confidence in the moral values that helped form her character. All they need now is the luck and humour we have enjoyed, and they will be truly fortunate.

Arabella Lewis: I stood beside my father on the morning of my wedding. I remember the house was finally peaceful. The wild screams of the briefly immaculate pages and bridesmaids careening around people's legs, were gone to the church. The loud, laughing, almost incomprehensible vowels of my relations reverberating around me, were just an echo in my head.

I stood in the shade of the hall, in my large white dress, balmed by the soft breeze and the calm smell of the garden drifting through the front door; looking out at the gnarled, blossoming apple trees and the laden peonies, translucent in the English summer sun. I ate a sandwich and contemplated images of myself as the "fatted calf" or sacrificial lamb, dressed for the feast with little white paper crowns, ready to be handed over from one man to another.

I enjoyed being the centre of attention, a rare thing in our family where everyone seems to be competing to be heard without bothering to listen. Maybe that's why I set off for America. It doesn't seem to have helped communication between my father and me—now there is just less opportunity to make myself heard. Maybe the distance I am putting between us through my marriage will give him the chance to look at me from another angle. Will he look beyond what I suspect is his indulgent love for me as his daughter, and evaluate me critically as a woman, or even empathize with me as a "small businessman"?

Oh, to tell him how much I love and admire him, how he is responsible for my deep-rooted values of fairness and honesty. It was from him that I learned self-discipline, stamina for hard work, generosity of spirit and curiosity

for people and history as we tramped across beloved Anglesey's hills, buffeted by salt wind and sea spray, to look at stone circles. I revel in his sense of fun, while my toes curl at some of his jokes. I feel like a fellow bacchanalian, sharing his love of good wine, good food, good friends; and a fellow conspirator, understanding his wry self-effacing humour while others look mystified.

I remember the memorable wedding he gave me, his indulgence in my whims; the church like a heavenly field, filled with cowparsley and sweetpeas, my stubbornness, my derision of his suggestions. Did I hurt him through this beautiful but final confirmation that I've chosen to live differently, in another country, with someone to whom I've given my heart and soul without a glance back?

Looking at my hands, I remember. Daddy and I both have the same broad, square, rather ugly hands. I love my hands.

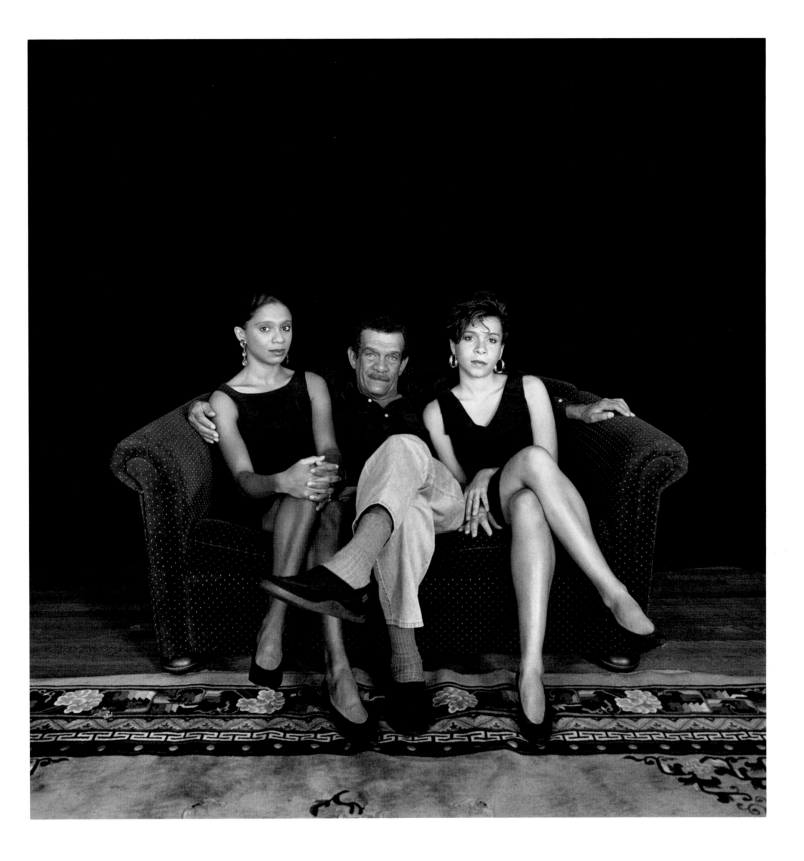

Derek, Elizabeth, and Anna Walcott

Poet

Boston, Massachusetts, 1990

Jack and Caroline Lang

Minister of Culture, Minister of Education / Editor
Paris, 1992

*J*ack Lang: I have never questioned my relationship with Caroline, which, it goes without saying, is tremendously valuable. Caroline is a demanding conversationalist and a remarkably constructive critic. Near or far, she has always been connected with all I do. She is a landmark. I do not know whether I know her as well as she knows me and that is just as well; children should have a certain reserve with respect to their parents. I feel myself completely at one with her.

*C*aroline Lang: We are very close. My father and I have almost no need to speak in order to understand each other, and mostly we react in the same way to events, to people and to things. I inherited my passionate temperament from him. I think my father has always conceived of our relationship as one of give and take. It is very lucky to have a father endowed with a rich personality and later to find one's own way. To the outside world our relationship might seem to epitomize friendship, but to me he is primarily a father, my father, who made me and guided me in life.

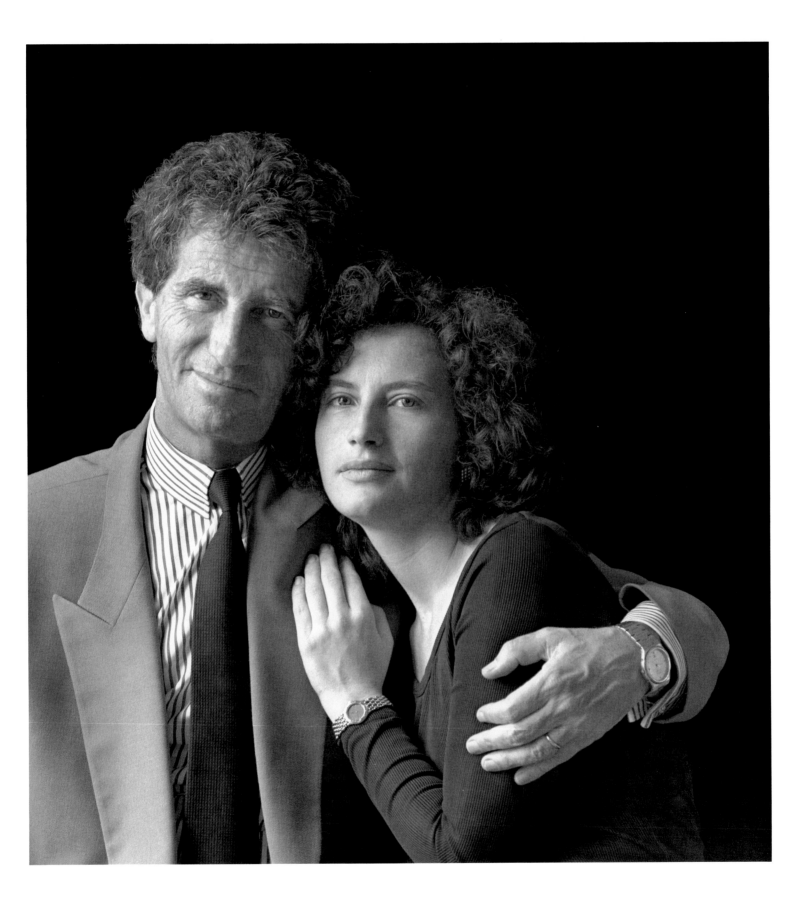

Leo Castelli and Nina Sundell

Art Dealer / Arts Administrator, Curator
New York City, 1992

*N*ina *Sundell:* My father is a quintessential optimist: he revels in the present and trusts in the future. When I was a teenager, grieving over some disappointment whose cause I have long since forgotten, he told me, "Perhaps there's a great opportunity waiting for you, and getting what you want now would make it impossible to do something else much better later on." That was what had happened to him. An immigrant who became a major force in the cultural life of the United States, he believes in and embodies the American Dream.

When I was a child, I admired and took for granted the breadth of his knowledge; knowing everything seemed to be an attribute of adults. He could recite poetry in three languages; he had a great fund of silly jokes, and he was as handsome as a movie star. I thought he was just about perfect.

I was the first beneficiary of that extraordinary combination of the sense of history, the ability to embrace the new, and the complete self-confidence that has enabled him to joyfully introduce generations of collectors to the most challenging contemporary art. He taught me that art has meaning, that it is a source of adventure and delight, that it reveals the past and makes sense of the present. There's no greater gift a father could give his child.

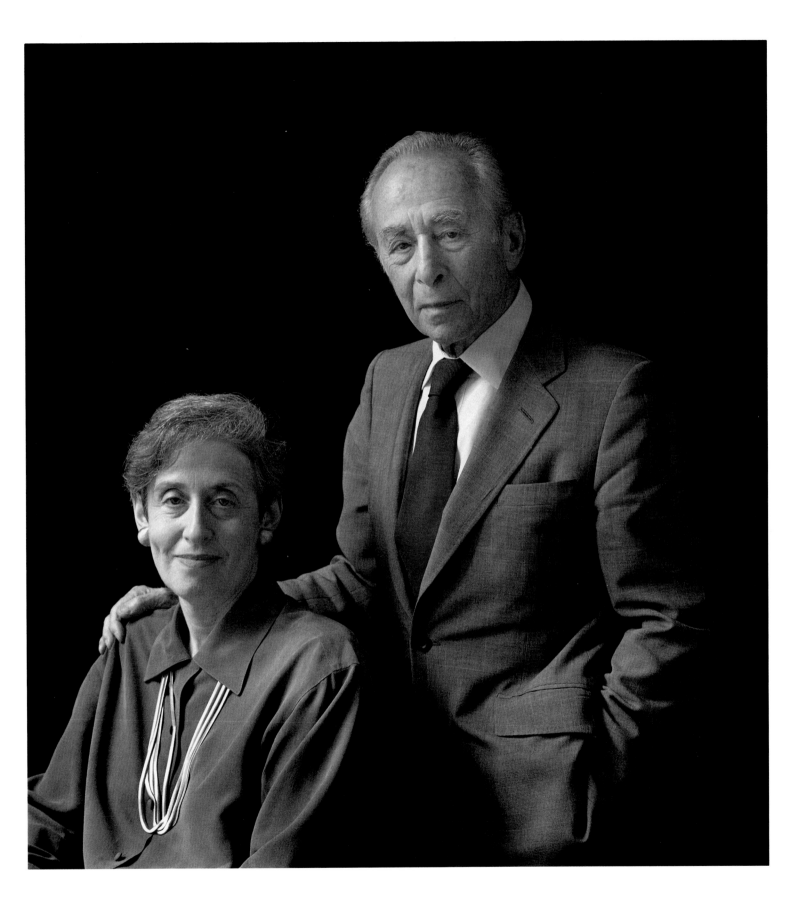

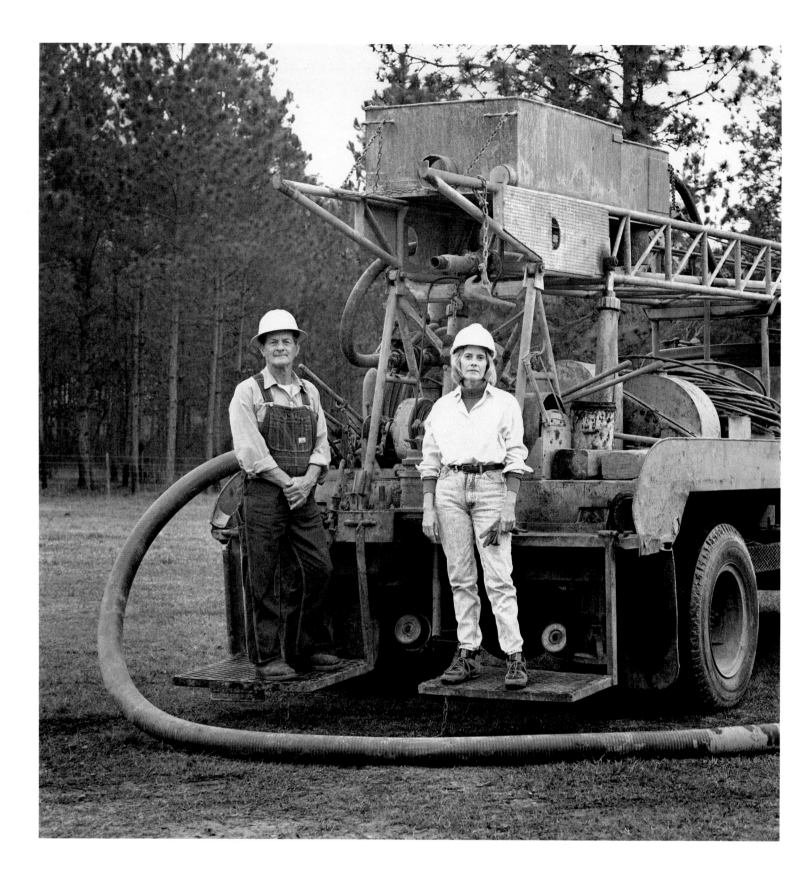

D.W. Gearen and Darlyn Dugas

Well Diggers
DeQuincy, Louisiana, 1991

D.W. Gearen: My business began in 1952. It started out as a small business and through the years my children became involved.

My two sons were raised behind the rig. They later formed their own business. At that time I had to seek new help, and my daughter volunteered. She was already working in the office as my secretary and helping my older son work on wells.

Through the years it has been a challenge—sometimes hectic but always rewarding.

*D*arlyn Dugas: When I volunteered to help Dad I was a little skeptical as to whether or not I could do the job, since it was a lot of physical labor. But Dad assured me I could do the job. He always has such faith and confidence in me.

It turned out to be the best job I ever had, maybe because I admire and respect my boss so much.

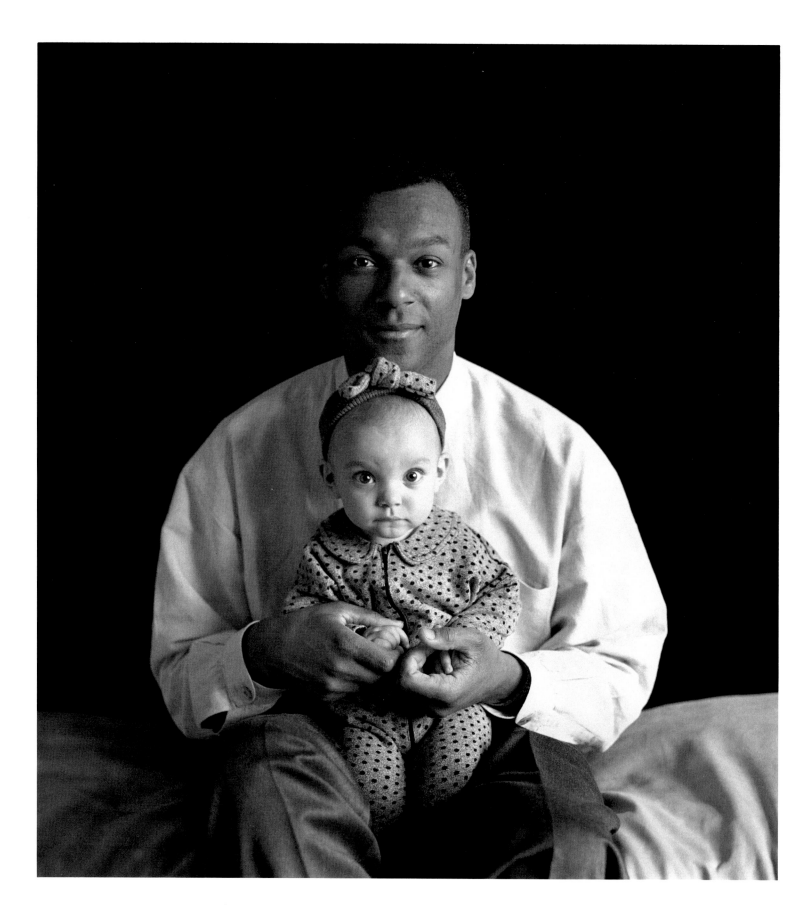

Colin and Ruby Salmon

Actor, Musician
London, 1993

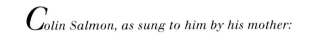Colin Salmon, *as sung to him by his mother:*

If you meet a fairy
Don't run away
They won't want to hurt you
They only want to play

Show them round the garden
And round the house too
They like to see the kitchen
I know they always do

Find them a tiny present
To give them when they go
They love silver paper
And pretty ribbon bows

I knew a little girl once
Who saw twenty-three
Playing in the orchard
As happy as can be

They asked her to dance with them
To make them twenty-four
She ran to the nursery
And hid behind the door

Hid behind the nursery door
What a thing to do
She grew up very solemn
And rather ugly too

So if you meet a fairy
Remember what I say
Talk to them nicely
And don't run away.

Cornelius and Cybèle Castoriadis

Writer, Psychoanalyst

Paris, 1991

*C*ornelius Castoriadis: This woman. This love. This swelling womb. Plans and daydreaming. The accidents. The birth pangs. A child. A daughter.

Before a newborn baby, women are usually in ecstasy. But for a man, at least for me, unlike a kitten or a lamb, a newborn human baby is ugly. A strange, big frog-like creature, more wrinkles than skin. Only its almost-nonexistent nails are pretty.

Then gradually it smoothes out. Still, for months and months, it mostly sleeps or cries. Sometimes, it smiles.

Suddenly a recognizable expression forms on her face. Sparse hair on the head. Intense and severely thoughtful—eyes, forehead, mouth, chin—she looks in the photos of the time like the famous picture of an aging Hegel: fathoming the meaning and the meaninglessness of the surrounding flux. Will she ever recover this pristine intensity of the glance? She will, in this photograph.

Babbling. Gesturing. Crawling. Syllables. Words. The first "sentence." Then the sprouting and blossoming. The rediscovery of the world through her eyes. Strange world, so different. We call progress and growing up the assimilation, this ontological decay: her world starts resembling ours. She becomes like us—but not quite. Miracle and banality relentlessly alternate. The impossible dream: keep the miracle intact, eliminate the banality.

Still. Each year brings some new miracles. And new hurdles. For endless months you despair: she will never go over it. Then suddenly, unexpectedly, she jumps. She did it.

The last: for years, playing the piano or the harpsichord with some independence of the two hands was impossible. Then, a few weeks ago, walking by her room, I don't believe my ears. A Bach fugue. An easy one, sure. But a fugue.

Would that it last forever. It will. But I will not be there anymore.

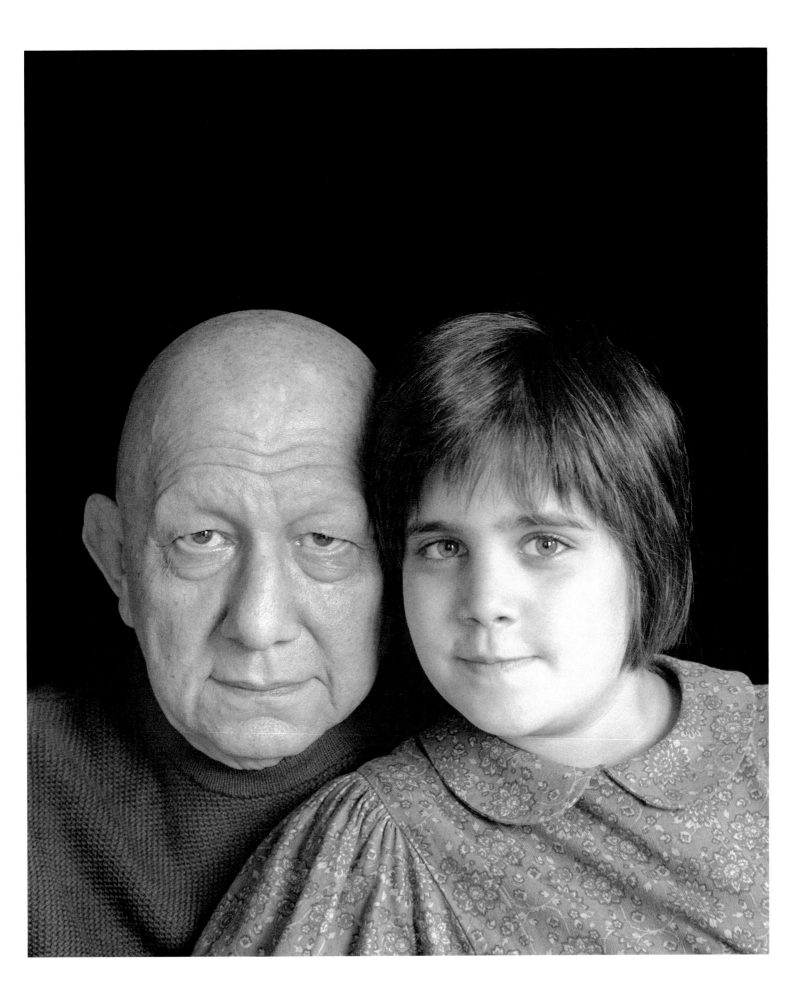

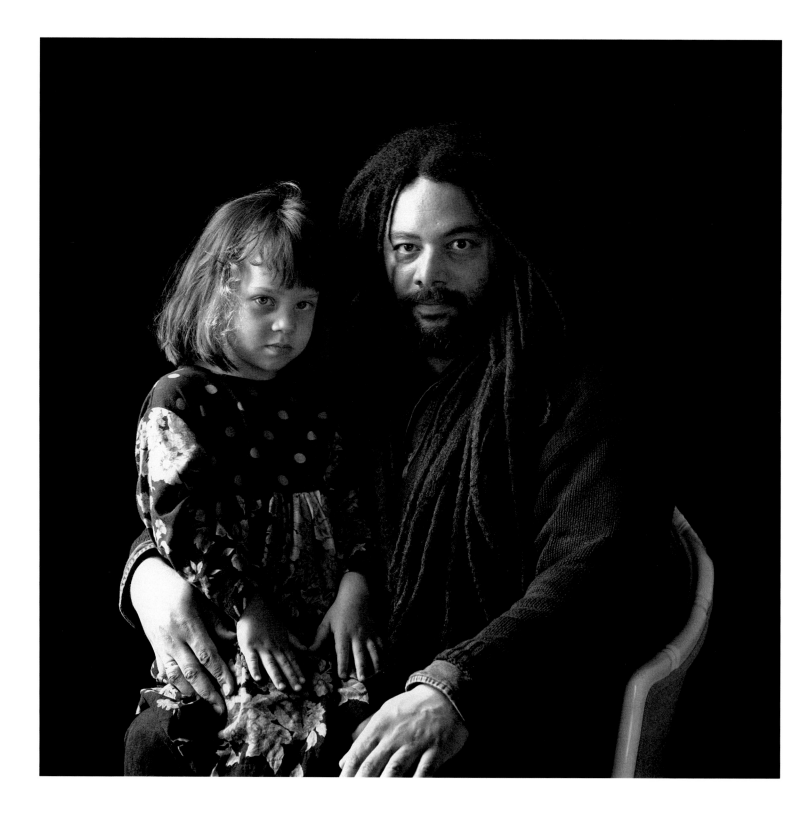

Paul and Cora Gilroy

Writer

London, 1992

*P*aul *Gilroy:* Cora has always seemed to be completely in command of herself. This comes across in numerous small ways: her resolute choice of clothing each morning, the determined way she wanders off with other families when we go to a park or to the beach, and her systematic preference for the company of other girls. I admire, perhaps even envy, the way she has cultivated an unusual degree of autonomy as well as the amazing equilibrium that goes along with it. I think these qualities are unusual in someone her age. They make her rare moments of dependency on me all the more precious. I savor them while puzzling over her independence and her certainty.

Dustin H. Heuston, Hilary, Kelley, and Kary Heuston, Kimberly B. H. Sorenson, and Heather Rosett

Educator and Chairman of The Waterford Institute
Salt Lake City, Utah, 1992

Dustin H. Heuston: My daughters have never been able to avoid our commitment to education. My wife and I have dedicated our lives to the concept of providing the finest possible education for all children no matter what their economic circumstances. Our research has increasingly centered on the use of technology, but from their births, our children have spent most of their years in schools that either I or my wife have run.

As part of our school design, we have had a strong interest in seeing that our daughters and other girls were treated identically to their male counterparts in terms of developing their talents. One of the hallmarks of our schools is to have children in science laboratories as early as the second or third grade so that the girls discover that they love science before they decide they are girls and should not. At our research school in Utah, my wife will not allow the girls to become cheerleaders, and instead they must play in the sports themselves.

We have been fortunate in being alive at a time when women have been given extraordinary new opportunities and we have watched with delight the growth of so many fine women in our educational systems. Three of our girls are currently working on their Ph.D.'s and a fourth is a teacher, while our youngest is just now finishing college. We hope that they have felt our love and reverence for education, and not felt pressure to perform because of their parents. I still remember Kimberley at a young age saying, "How would you like to be the daughter of a perfect mother and a father who is going to change the history of education?" That was just a year or two after she asked her twenty-three-year-old mother (she was five) what it was like in the olden days. Now, having raised five daughters and worked for twelve years with schools that concentrated on educating women at the elementary, secondary, and collegiate level, I have gained a great appreciation for the unique talents of women, as well as their difference from men.

Unlike men, who are so binary in their approach to life—they pick up and drop interests and relationships rapidly and prefer to concentrate on one issue at a time, e.g., their work—women can handle a multiplicity of complex issues simultaneously, including extended families, with all the emotional rituals involving birthdays, anniversaries, graduations, deaths, marriages, etc. And over the past two decades, they have expanded their repertoire by adding professional careers to their family interests and here, too, they have brought to bear spectacular talents, although I hope they can use them without feeling they have to out-macho the male pachyderms.

I marvel at how they bring their genius to our living environments as they relish the use of colors (clothes, wallpaper, books, food, art, flowers, etc.) that men rarely notice. Of course it is not fashionable now to acknowledge that

women are good in these areas because such talents rarely lead to economic gain. But there is little question in my mind that men are gradually civilized by the women around them who have such a unique feeling for their living environments.

Also, I honor them for understanding the importance of education for themselves and their children. While the women in a community can tell you the merits of the various local schools and the teachers working there, men are clueless unless there is a simple index like a basketball or football score. But in the end, no man can ever understand fully the delicious complexity of women, particularly as they are growing through adolescence. To my dying day, I will be delighted with the thought that all the school authorities combined are unable to break one eighth grade girl who is determined to be herself.

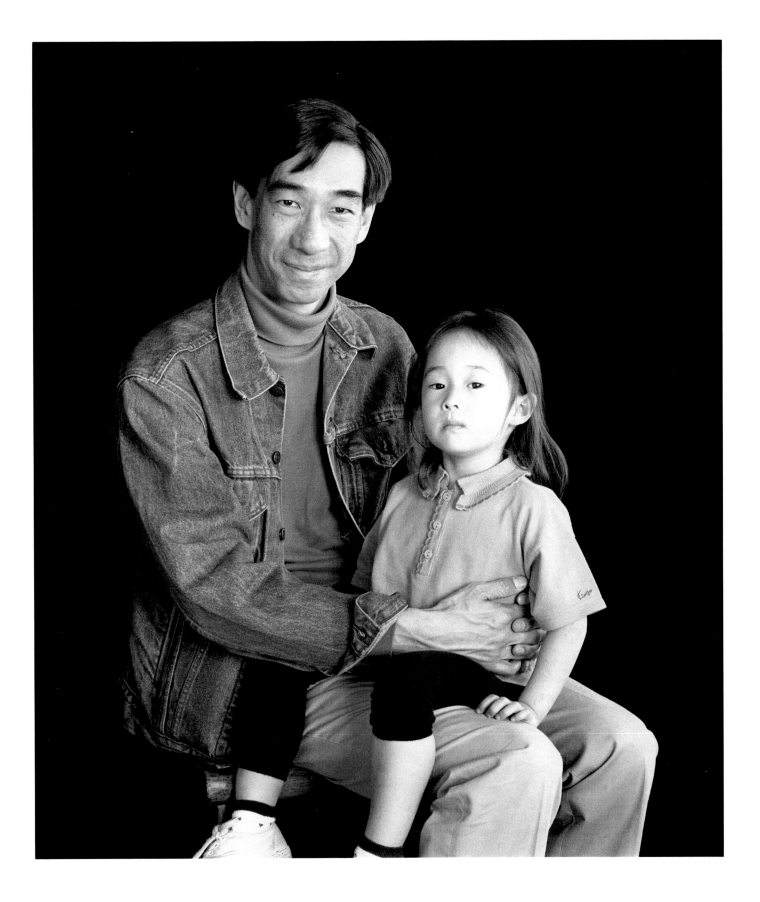

Chien Chung and Olivia Pei

Architect
New York City, 1993

Jack and Celestia Peregrina Loeffler

Ethnographer
Santa Fe, New Mexico, 1991

*J*ack Loeffler: I was forty-four years old when my only child was born. I called her Peregrina. She and I have wandered wilderness trails together and floated wild rivers. We have camped in deep canyons and passed hundreds of nights beneath the star-bright sky of the high country. We live in a mud house and can look to the western horizon a hundred miles distant. We share the deep love common between fathers and daughters, but there is more than that. We share our lives and our common quest to roam tracelessly about this mother planet we call home.

*C*elestia Peregrina Loeffler: I love my Dad very much, and if anything ever happened to him, I would be sad. I wish that he would live forever. He is the best Dad anybody could ever have. Even my cat likes him (and I can see why).

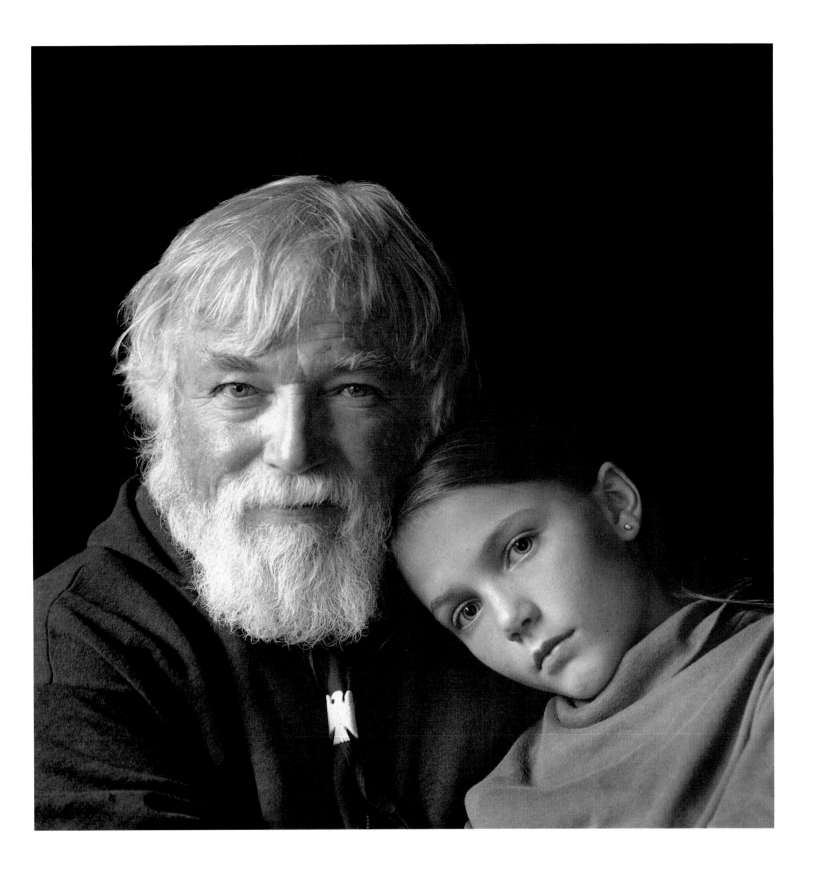

Paul E. Corbello and Paula Derwin

Retired Pipe Fitter / Schoolteacher
Lake Charles, Louisiana, 1991

Paula Derwin: I have spent most of today thinking about the relationship between my father and myself. I don't think I have ever given it any serious thought. Dad is not a complex person. There is never any "grey area" with Paul Corbello. You always know where you stand with him. As the oldest of two girls, I thought my little sister got all of his love. Of course, that was not the case at all.

Allen and Annie Shawn

Composer
North Bennington, Vermont, 1992

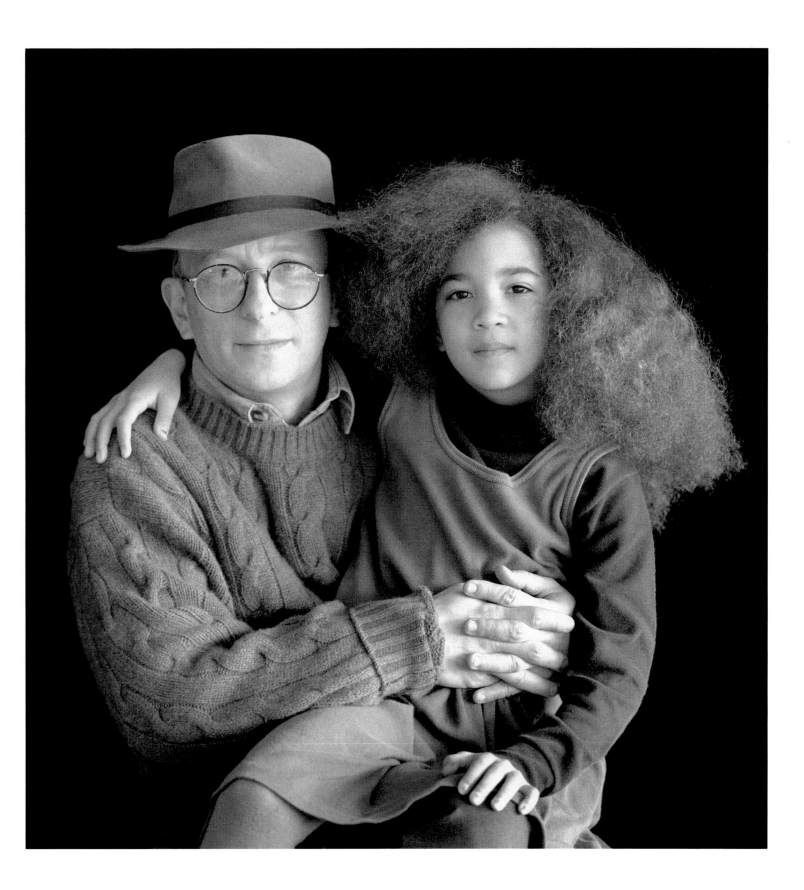

The Honorable Harry A. Blackmun and Nancy Blackmun Coniaris

Supreme Court Justice / Clinical Psychologist
New York City, 1993

Harry A. Blackmun: A German named Wilhelm Busch, more than 100 years ago, said: "Becoming a father is easy enough, but being one can be very rough."

Having had three daughters brings home the fact that there is at least a little truth in that statement. Nevertheless, despite the concerns and worries that parents always entertain, having daughters can be a joy indeed.

Mrs. Blackmun and I have been favored with the facts that our three have broad interests, are active and lively, participate (in the true sense of that word), and thus have made life particularly appealing. One has noticeable intensity, another a sense of fairness I have seldom seen equaled, and the third a natural ability to write and a deep sense of adventure that has carried her over the world. All are activists. None is retiring. All can be critical, but gently so. It has been a good "ride" as they have grown up and moved into the responsibilities of adulthood and parenthood.

I should add that at no time has any one of them ever tried to influence me in decision-making. Each is interested in what is going on and has ideas and convictions, but decision-making is for me, they say, and not for them.

Nancy Blackmun Coniaris: It has been complicated having this man for a father. There have been long stretches when I have wished we could just be an ordinary family—this was even before he became a judge, let alone a Justice. A person doesn't attain his kind of distinction without exceptional dedication. Dad has been married to the job as far back as when I was in kindergarten. It has been hard on Mother, but at least she was an adult when she chose to join him, even if it is impossible, really, to know in advance what the cost of any major decision might be. My sisters and I didn't get to choose. We were born into it.

A lot of people assume it is wonderful to have a famous Justice for a father. "Wow, it must be so exciting." "Oh, you must be so proud." It is exciting, and I am proud, but there are costs. It is impossible, for example, to separate out whether, or how much, it matters to some people whose daughter I am. Such a parent becomes a kind of commodity, and arrangements with others and within oneself can begin to feel more like business deals than relationships. There is also living in his shadow. No matter what one does, it can't compare. Perhaps the hardest thing is having to compete with the nation's business. Who am I in the face of issues affecting whole big groups, even millions of people? In the abstract, this is sometimes manageable, but then there will be an article in

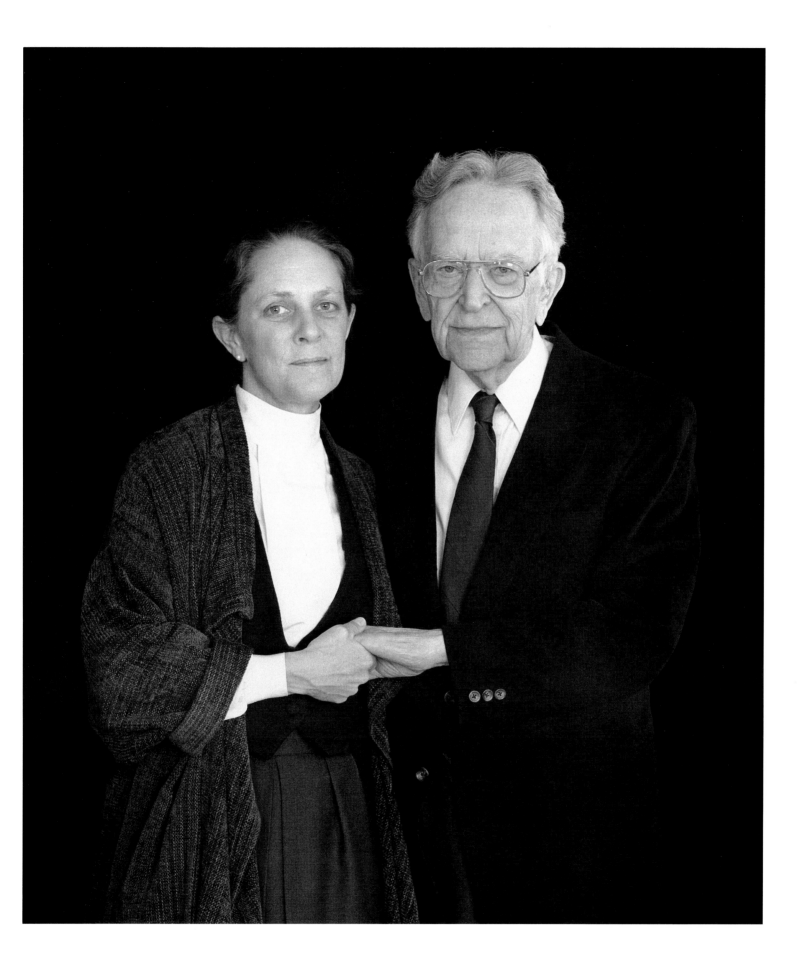

the newspaper about an excruciating case. I will realize that it was this case that was behind the fatigue and the edge in his voice that made me feel like a nuisance during the last phone call, and my own needs will seem small by comparison.

About two years after I was married, and after Dad wrote *Roe v. Wade,* he was scheduled to come to Boston to give the keynote address for the annual meeting of the American College of Obstetrics and Gynecology. He had never seen my house. I was in the early months of my first pregnancy, working full time, feeling exhausted and seasick. It was spring, and the buildup of pressure at the Court to finish the year's cases had begun, but I might have been able to invite him and Mother to drive the hour and a half round trip to where I lived if Mother hadn't said, "Don't ask anything of him, Nancy. He's terribly tired." So I made the trip to Boston three times in 24 hours, taking most of a day off from work to be able to hear him speak. When my baby was born, he did not come to see me. I took the baby to Washington to see him.

At such times it has been hard to sort out what is important. On this occasion it was a question of obstetrics in the abstract or in the concrete. Do I take care of the author of *Roe v. Wade,* and by extension all those women who don't want to be pregnant and the obstetricians and gynecologists who provide their medical care, or does he take care of the woman who is his pregnant daughter and the baby who is his grandchild? On another occasion when the father seemed to have gotten completely subsumed by the Justice, I complained to a friend that my dad might be a great American, but he was a lousy parent. The friend responded, "There are a lot of lousy parents, but not so many great Americans. Maybe you had better be content with what you have." This kind of thing has been confusing. What am I supposed to do with my anger, despair and frustration?

And yet, his are the most comforting hands to hold: square and warm and responsive. I like it that my own hands, not especially beautiful for a woman's, look like his. At the onset of adolescence in eighth grade, a difficult year for most new teenagers, he smoothed my path by reading me Sherlock Holmes and helping me prepare for, of all things, home economics quizzes. We got an A, of course.

He is a loyal Harvard man, but his favorite piece of music is the Yale "Whiffenpoof Song." He sang it to us in the rocking chair when we were little. He sang it with great seriousness every night in the shower, while we listened and giggled outside the door. I sang it to my own babies. Hearing even a phrase of it now brings tears to my eyes: "We are poor little lambs . . ." It is a nostalgically old-fashioned, mysterious and complex song, but I cannot remember being too little not to know its several sections of melody and all of its words. Its beauty and sadness are inextricably tied up with the daddy who goes back as far as I do.

We talk on the phone a lot, in a way that is best captured by the nearly untranslatable German word "gemut-lich." "Gemutlich zusammen"—warm and comfortable together. He has called more as he has gotten older, little conversations scattered through the week. I have learned how to make him laugh, and then he will end the call by saying, "Oh, I feel so much better now," and indeed, I can hear it in his voice. I hate letting go of him to hang up, dreading that point in the future when there will be no more calls.

We went for a walk in Washington on a blustery December day, crossing the Potomac to Georgetown. I teased that I had to hold onto him tightly to keep him from being blown off the bridge, such a little wisp he has become. At eighty-four he is the incredible shrinking grandfather. But he hasn't shrunk in character the past couple of decades. He has grown. How many people do that, starting at an age when most retire? He has been a model of principle, wisdom, compassion and respect for the truth. He has stood up for people without much of a voice—battered children, welfare families, prisoners, homosexuals, minorities, women. In his autumn years he has risen above day-to-day confusions. He reminds us of what it can mean to be a responsible, civilized person with a perspective born of experience and a sense of history. On issues that entangle the rest of us, he listens for the universal principle, a small and modest figure speaking to what is important in dramatically simple, ringing language. It is no accident that his own hero is Abraham Lincoln, but he has been a hero himself.

There it is, *in statu nascendi:* the difficulty of hanging onto my own experience of him; too often, of even getting hold of him. He slips through my fingers, off the bridge and onto the stage, where he is a great American giving a transcendently moving speech. In being a member of his audience, especially in the glow of these final years when he is a sitting Justice, there is at least admiration. If it is no substitute for my occasional dad, it is something that provides an avenue to him, and something that binds us, his audience, together. I try to find comfort in that, in sharing it with those who also love him, and in my connection with someone whose voice we need.

Although in many ways he has never been here—and I cry about that, for him as well as for myself—I will miss him terribly when he is gone.

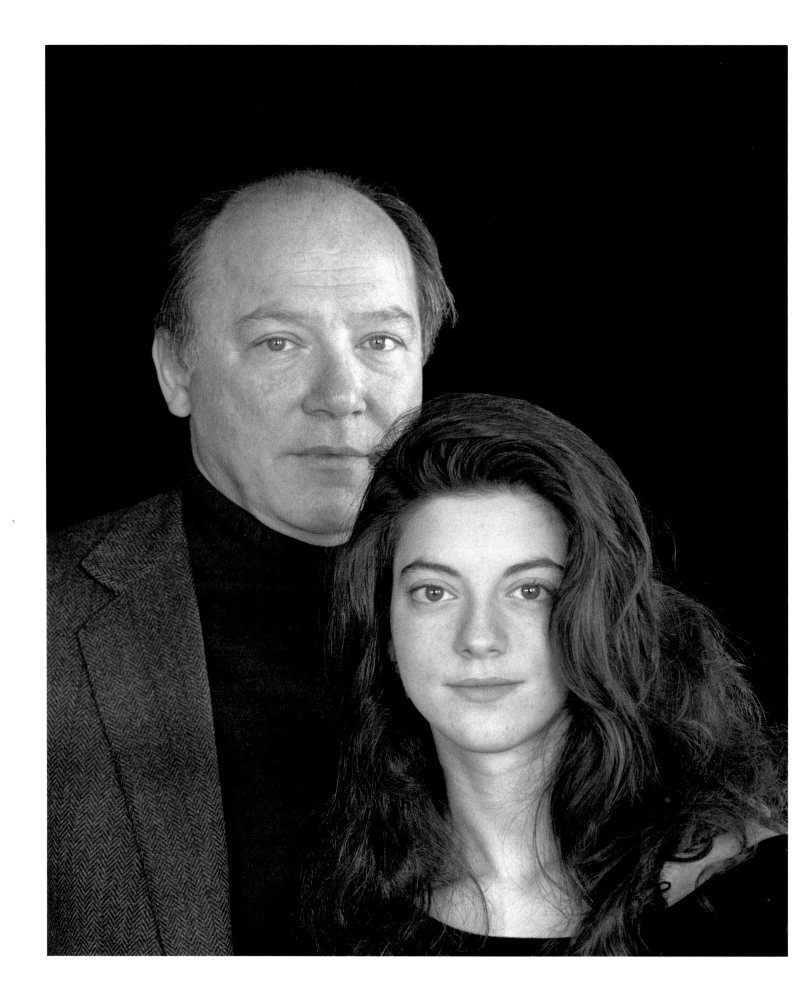

Vincent and Aleksandra Crapanzano

Cultural Anthropologist
New York City, 1991

Daughter: Why should we do a dialogue?

Father: It's easier.

Daughter: Why is it easier? Won't we be self-conscious?

Father: Sure, but we should start with . . .

Daughter: With what?

Father: A problematic?

Daughter: Oh, Daddy!

Father: When does a daughter first know her father as a father?

Daughter: You really meant a problematic.

Father: Not from birth—when a father knows his daughter.

Daughter: How do you know?

Father: When did *you* know I was your father?

Daughter: I've always remembered your being my father. [Turns to Mother] When did I know my father was my father? Did you tell me?

Mother: No. You always knew. The first time your father really knew you were his daughter—you must have been a month old—he carried you around the house showing you all the books. You liked the red ones.

Father: No, that's not true. I always knew.

Daughter: It's a good thing I liked books.

[Mother and Daughter laugh.]

Mother [to Daughter]: Do you remember the opera your father wrote for you? [Singing] "This is the opera of Oscar and Ferdinand. Oscar is orange and Ferdinand is green—oh."

Daughter [to Father]: Write that down.

Father: That won't mean anything to anybody because no one will know I wrote that for you when you were a baby.

Daughter: Write it down anyway. I'm glad we got Mommy in.

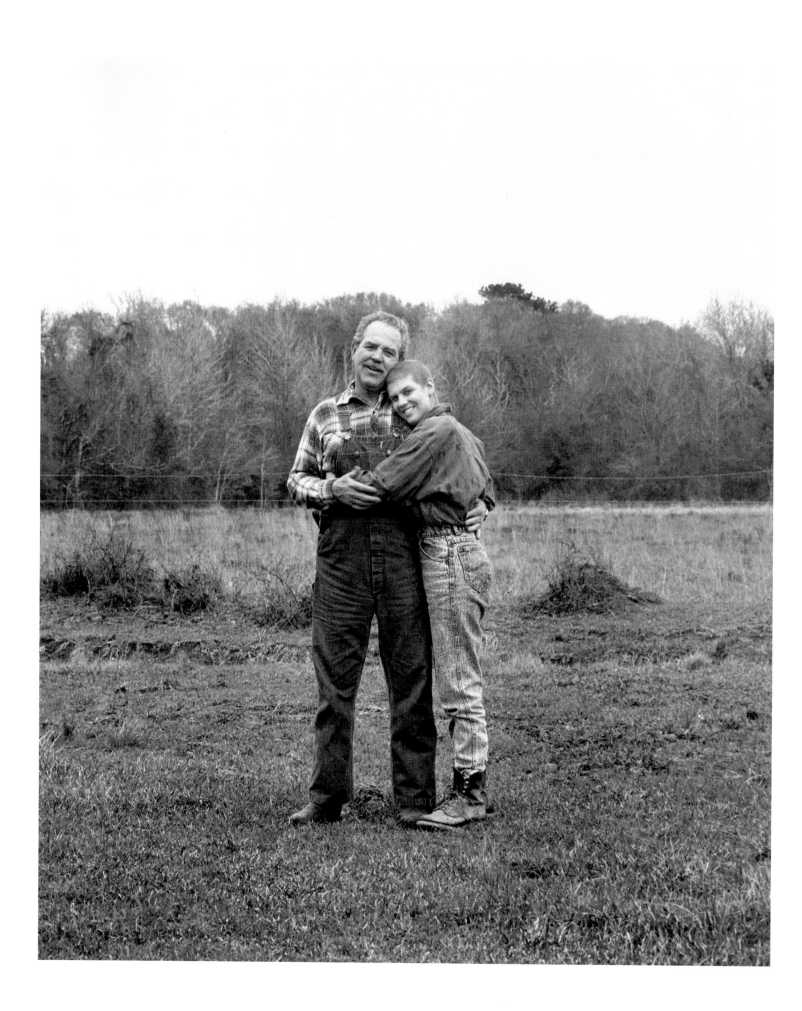

James Vincent and Jon Marie Gearen

Pipe Fitter / Housewife
Sulphur, Louisiana, 1991

*J*ames *Vincent:* As husband and father, the cries of your first-born make you swell with pride. As she goes through childhood—first grade, prom night—you wonder if all the things you've tried to instill in her—values, manners, pride in self—will ever come through. Then all of a sudden you are walking her down the aisle to a young man and you think, "She's turned out well and my job is complete." Then, suddenly, that sweet babe you held in your hands becomes ill with cancer, and she's again become that fragile child in your hands. Chemotherapy is a harsh treatment. It robs you of strength, hair, all that we take for granted. And finally, as on the day she was born, the sense of complete pride and joy when the tests say ALL CLEAR.

*J*on *Marie Gearen:* Growing up in a loving family and with a Dad who believed in strong discipline taught me a lot about life. My Dad was there for most of my "firsts": first steps taken, first bike ride, and he was there to give me away in marriage. Now, I'm a grown woman; he is still there, and all the lessons have paid off. Without that discipline and love, I would have never been able to "discipline" myself and overcome cancer.

Michael and Amanda Klück

Woodcarver
Cerrillos, New Mexico, 1991

*M*ichael Klück: Amanda has an unbounded curiosity. The fact that everything is fresh and new to her makes me see things in a new way. When Amanda saw a butterfly for the first time, I felt as though I were a child again, seeing a butterfly for the first time. I am thrilled that Amanda loves nature and art in every form. Being an artist and nature lover myself, I feel a very strong bond with her.

There is nothing in the world like a surprise hug from Amanda and to hear her say, "I love you, Daddy."

*A*manda Klück: My daddy is special. He lets me play and paint in his studio and he takes me to school every day. I'm happy I get to do a lot of things with him. I love my daddy.

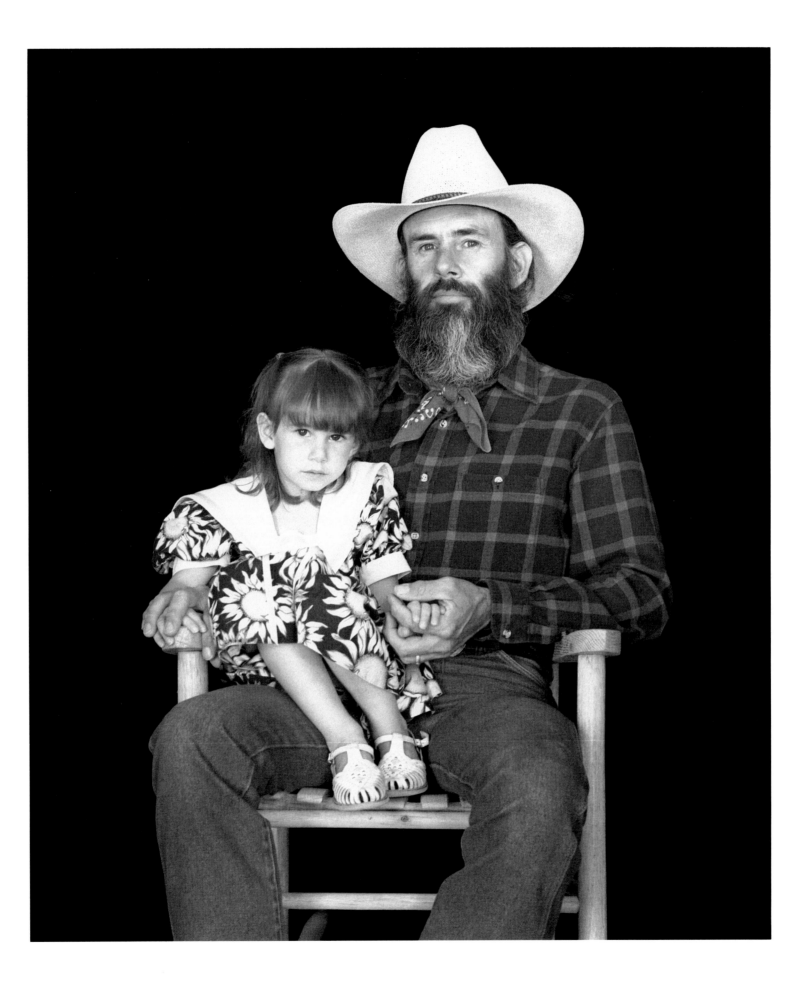

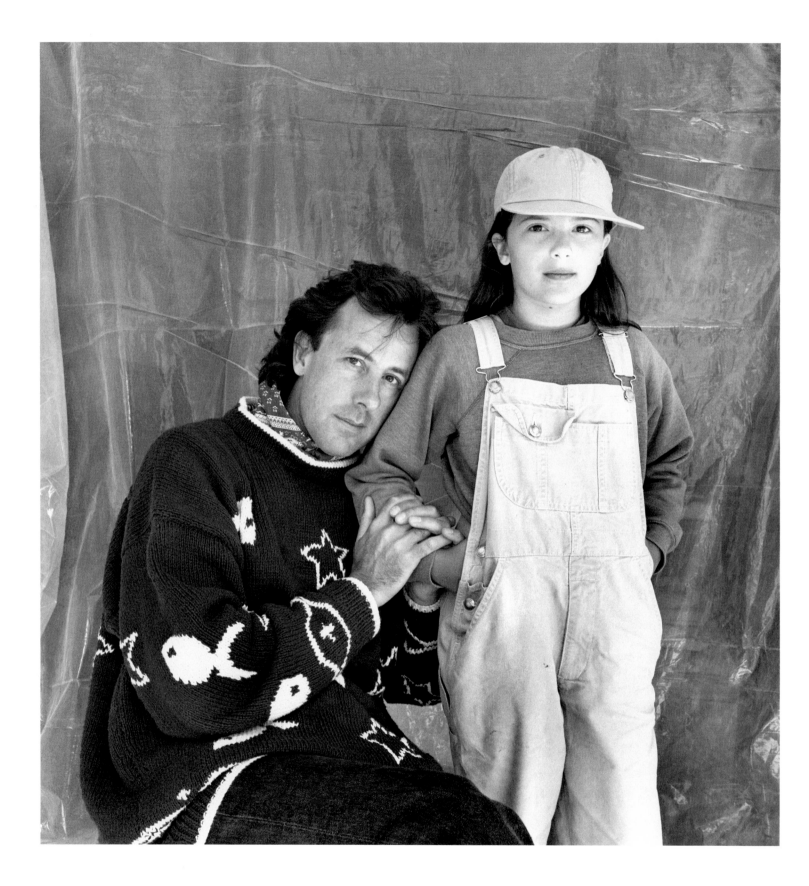

Peter and Chloe Marlow

Photographer
London, 1992

*P*eter *Marlow:* Chloe is twelve. Dad is forty-one, and last week he got in the mail nineteen kisses from Chloe written in tiny crosses at the bottom of a card she had made me which began, "Dear my one and only Dad . . ."

The photograph here was taken in Livingston, Montana, halfway across America and halfway through a three-week trip we made together from England. Now and again we go off together, just the two of us, to spend more than the usual weekends between Chloe's school-weeks and Dad's work-weeks. (Her mother and I divorced when she was three-and-a-half.)

And we always seem to have the best of times when not much is happening. Chloe would probably disagree, but we are closest when the most mundane of things become the biggest of adventures.

It has been a long journey together, not all of it easy, but all of it memorable in the best kind of way. Along that way we have built up a friendship and a relationship which I know would not have been the same if I had stayed in my role as the passive and helpful father, always there, but never really taking responsibility.

And it always seems to get better and better, from the low point—years ago, when after a week together, I'd wake up at night, confused, wandering around each room of my apartment, calling out her name, looking for her—to now, when I get such a warm and cosy feeling knowing that I can be Chloe's "one and only Dad."

So Dad wrote back with the package of things she'd forgotten to pack in her suitcase last weekend: "Dear Chloe, my one and only daughter . . ."

*C*hloe *Marlow:* My Dad is trendy and lives in London. He is building a new home—as in getting a warehouse and doing it up. I can't wait until it's built. My Dad likes planes—as in little ones; he used to have his own. My Dad is a photographer which means he travels. I went to America with him and it was always, "Hang on a minute. I just want to pop into the office." But I don't mind because I play on the computer. He is always backing into things in his car. When we went to Montana he backed into a car while someone was still in it! My Dad is very absent-minded. So am I. I get it from my Dad. My Dad takes me places in London. I must have been to every museum in the whole of London! My Dad drives me mad sometimes, the way he always says, "Lovely day for flying!"

But I still love him!

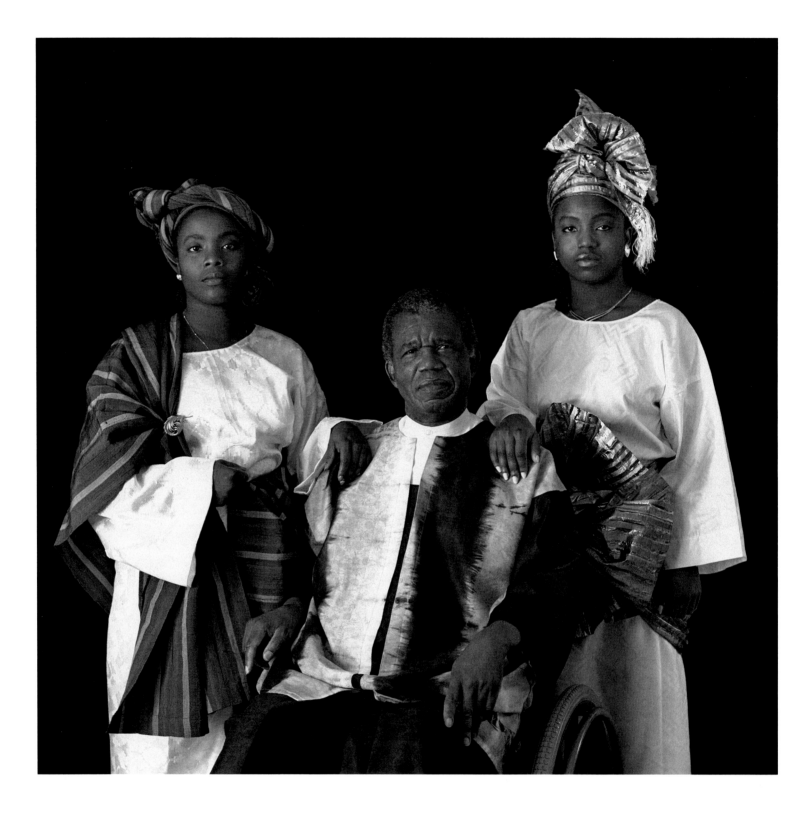

Chinua, Chinelo, and Nwando Achebe

Writer / Writer / Student
Annondale-on-Hudson, New York, 1992

Chinua Achebe: All my life I have had to take account of the million differences—some little, some quite big—between the Nigerian culture into which I was born and the domineering western style that infiltrated and then invaded it. Nowhere is the difference more stark than the western man's willingness to talk about his children. That foolishly garrulous father in a European children's story who exposed his daughter to untold danger and distress by telling an avaricious and cruel monarch: "My daughter can spin straw into gold" had it coming to him, my people would say. We are very reticent about our children. About the most outrageous question you can ask a parent is: "How many children do you have?" We count livestock, not children. But things are changing and changing fast with us; and we have been making concession upon concession even when the west shows no inclination towards the slightest reciprocation.

So I have learned to do what my father would never have done—break the reticence about my children. And to my shame I must admit that I am even beginning to enjoy the heady feeling of breaking a taboo and seeing myself come to no visible harm. Or so I hope.

My wife and I have four children: two daughters and two sons; a lovely balance that is further enhanced by the symmetry of their arrivals—girl, boy, boy, girl. Thus the girls have strategic positions in the family.

We—my wife and I—cut our teeth on parenthood with Chinelo. Naturally we made many blunders. But she was up to it: she taught us. At age four or five she began to reflect back to us the unhealthy racial attitudes she was absorbing from the books she read, which compelled us to examine them for the first time. We had assumed that all we had to do was go into the smartest department store in Lagos and pick up every attractive-looking and expensive European children's book in stock. Our complacency was well and truly shattered by the poison we now saw wrapped fancifully in some of those stories we had absentmindedly paid for and taken home to our little girl. The second lesson I learned was that if I wanted safe books for my child I had to write them myself. I dedicated my first effort to Chinelo and all my nephews and nieces.

Our second daughter and last child, Nwando, gave me a variation on Chinelo's theme eight years later. The year was 1972 and the place Amherst, Massachusetts, where I had retreated with my family after the catastrophic Biafran War. I had been invited to teach at the University and my wife had decided to complete her graduate studies. We enrolled our three older children in various Amherst schools and Nwando, who was two-and-a-half, in a nursery school. And she thoroughly hated it. At first we thought it was a passing problem for a child who had never left home before. But it was more than that. Every morning as I dropped her off she would cry with such intensity I would keep

hearing her in my head all three miles back. And in the afternoon when I went back to pick her up, she would seem so desolate. Apparently she would have said not a single word throughout the day. I don't quite remember how we came to make our bargain, Nwando and I, but we did. In return for telling her a Nigerian story on our way to school every morning, she agreed not to cry any more when I left her. Before long she added a further stipulation—a story also on our way home. I have never been more taxed in my literary inventiveness!

Chinelo and Nwando thus showed me how serious stories were to children and turned me into a campaigner for the rights of African children to their own story books. In 1987 I told a glittering gathering of African writers in Zimbabwe that every one of them owed our children at least one book. They applauded and went home and have done nothing about it as far as I know. If I have another chance of talking to them I think I will tell them what George Bernard Shaw told waiting reporters as he stepped off the boat in New York harbor: "Don't ask me what you should do to be saved; the last time I was here I told you and you haven't done it."

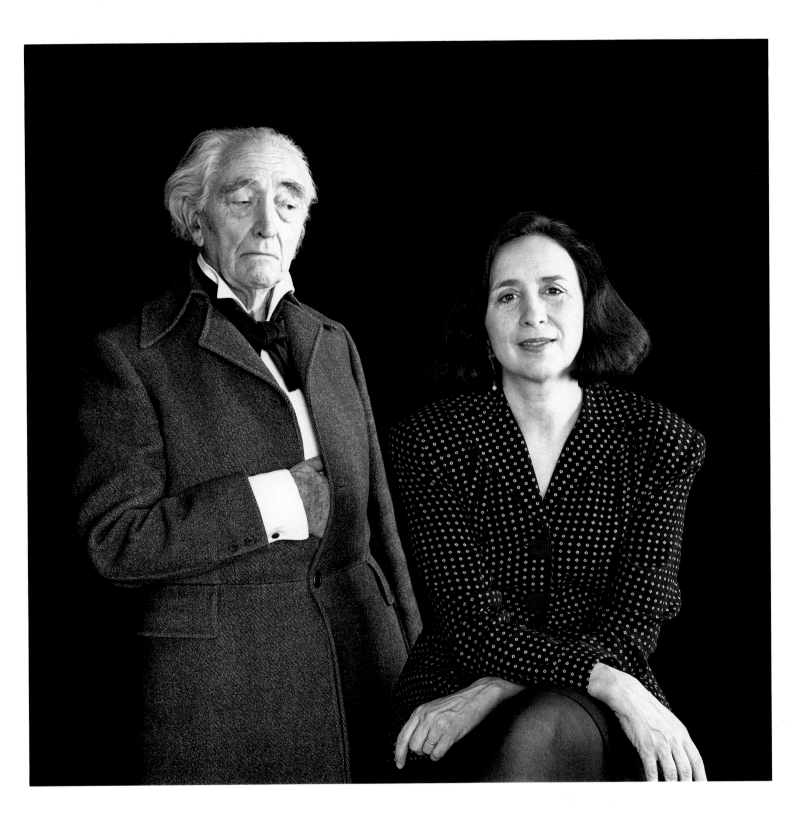

Niccolo Tucci and Maria Gottlieb

Writer / Actress
New York City, 1991

Dan and Johanna Welch

Former Buddhist Monk / Actress
Santa Fe, New Mexico, 1993

Dan Welch: Johanna was born as a sort of by-product or extra bonus of an American Buddhist experiment: Could men and women (and consequently, children) fly in the face of 2500 years of tradition and practice meditation together in a quasi-monastic community? The experiment was Tassajara, the Zen Mountain Center retreat in California. My first recollection of Hanna taking that first breath twenty-one years ago was of her wide eyes soaking in a new world with amazed delight.

As a kid I always liked to show off, particularly to a small captive audience, but I have always terribly dreaded having to perform in public. Now, I find it ironic that Johanna has chosen performing as a life endeavor. She is extremely perceptive, and while she's amiable and definitely fun-loving, there's also a quiet sense of intense self-reflection going on.

Three years ago, it came as an unexpected revelation to see her in a dramatic performance, conveying with unabashed certainty the role of a woman several times her own age. "Wow," I thought to myself, "how in the world can she *know* these things?!"

Johanna Welch: My father is always creating. I've enjoyed his weird sense of humor ever since I knew what a weird sense of humor was. "It's hard work having fun," is way up there among his guidelines to live by. His puns are one of my favorite manifestations of his creativity. He loves to play with words in order to stretch their meaning, and he quite often comes up with ironic, enlightening, yet subtle new interpretations of the ordinary.

Perhaps one of the things that attracts me so much to theater is the fact that it is meant to stretch reality, to entertain, and to challenge people to think. I love theater for its constant use of the imagination, its "willing suspension of disbelief." I love my Dad's sense of humor for just the same reasons. Great theater is provocative and questions what is real by creating life that is "unreal" on stage. It is larger than life, it embraces life, and yet it is life's mirror.

Dad will frequently introduce me to people by saying, "This daughter is related to me." And, yes, the apple never falls far from the tree.

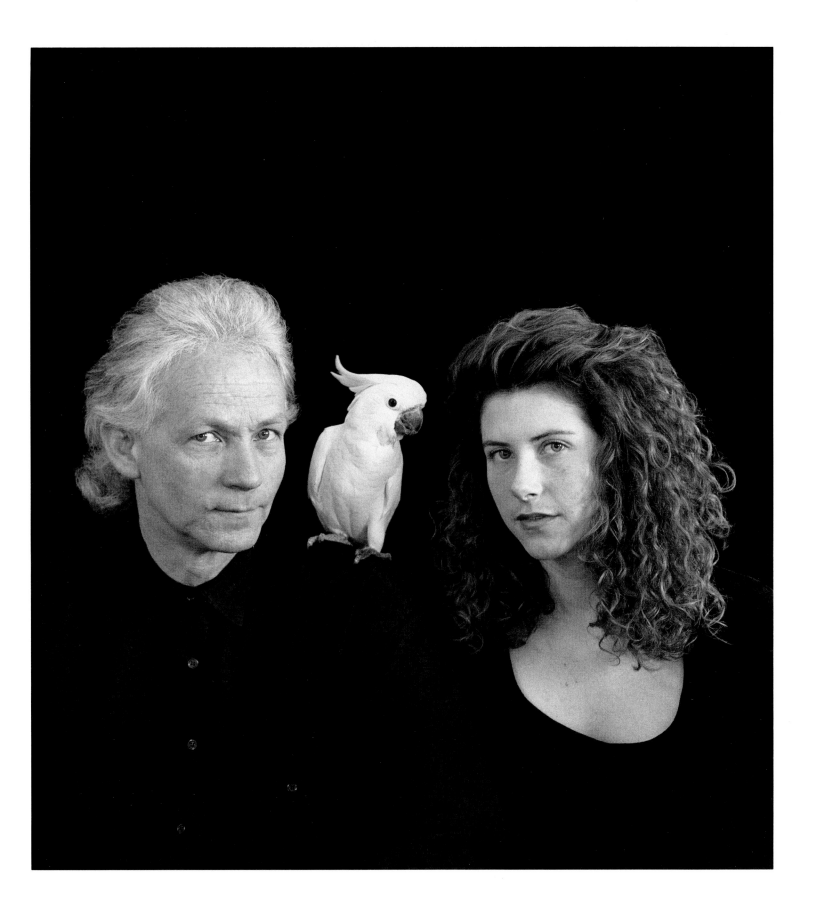

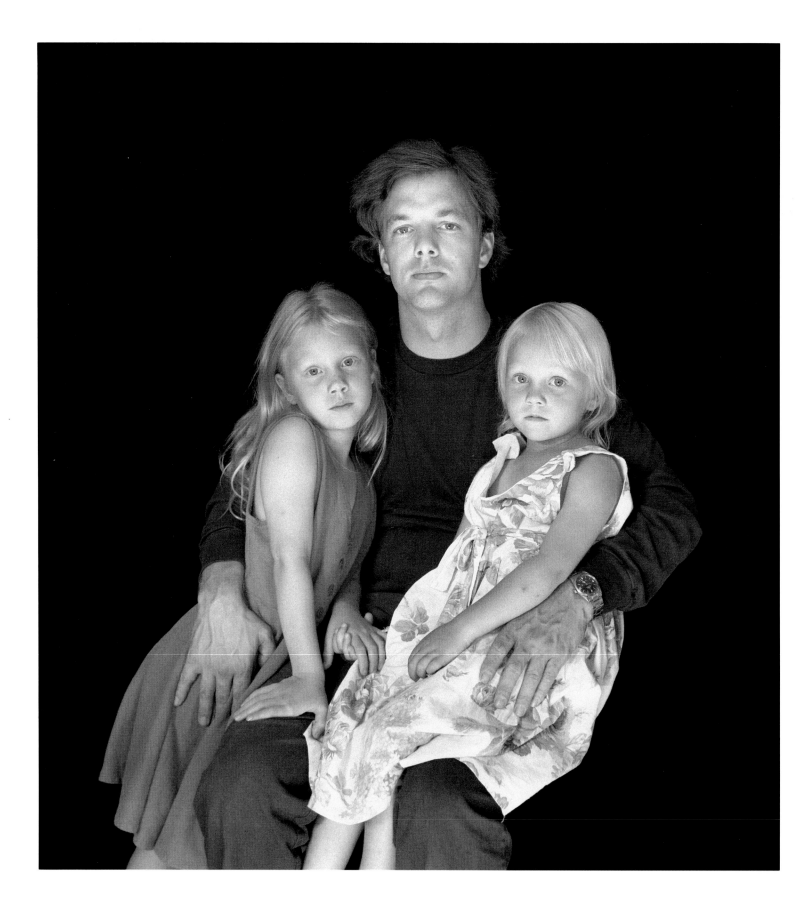

Thomas, Luned, and Rosamund Palmer

Printer
Newport, Rhode Island, 1991

*T*homas Palmer: Who are these little people who sit on my lap? Strange creatures that we have made, who live in the world that Dominique and I have cobbled together and in a world that they are making up for themselves even as I write. Luned is nine now, and Roz six. It seems at one and the same time that we have never lived without these two and that it was just yesterday that, childless, I prepared myself for fatherhood by thinking about Dada. Something I would soon experience and be helpless to prevent: total chaos. Life with Dada. Sure enough, these two are writing out our lives with us, turning our house into a colorized Merz building and filling it up to the ceiling with life. Now there is less chaos than there was five years ago. Chaos is turning into harmonic anarchy as we all bumble along into the future, bouncing off each other, weathering our teacup tempests and days of bliss alike.

Sir Eduardo Paolozzi and Emma Paolozzi

Sculptor / Jeweler
London, 1992

Sir Eduardo Paolozzi: Emma is the youngest of my three daughters, and the only one I see regularly. We meet at least once a week and she has become more a favorite friend than a daughter. A woman of colossal charm, she has a wide social circle which intertwines happily with mine.

The other day I came across a photograph of her as a child. I could not make the connection between it and the extraordinary person she has become.

Emma Paolozzi: I'm not sure if it's a family thing or if we would be good friends anyway. We are into many of the same things and obviously he has influenced the way I approach my work—teaching me to, like him, always remain curious and open to learning.

My favorite times with Pa are spent either with our close friends or on our own, wandering through markets or bookshops.

I am very aware that he will always remain the biggest influence in my life. He's my father but he's also quite simply my best friend.

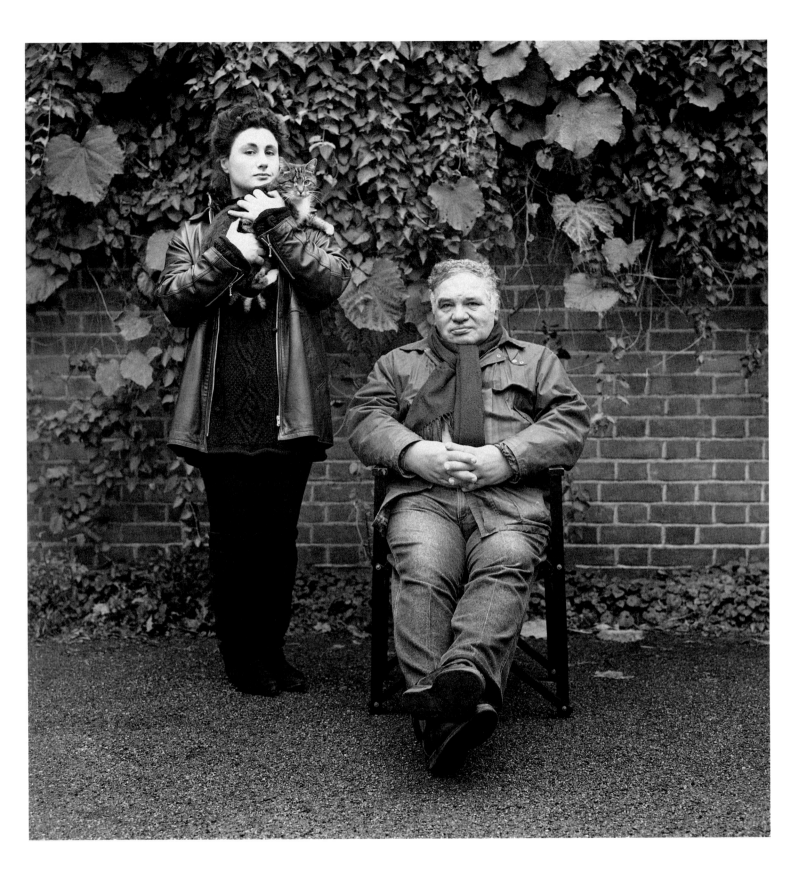

Tom and Anita Kirn

Retired Kodak Product Designer / Legal Secretary
Rochester, New York, 1992

*T*om Kirn: Anita grew up in another state. During her formative years we saw each other only briefly and at extended intervals. Now, in her college years, she lives with me and it is with a great deal of joy that we are finally getting to know each other. It is an ongoing process.

Genetics works. In addition to becoming her own person, I see in her many strong reflections of myself.

*A*nita Kirn: My father is one in a million. I mean that. No one has a relationship with their father like I have with mine. My father is, I guess, more my buddy than my father. He wasn't around while I was growing up, and it is only in the last five years or so that I have gotten to know him. When I moved back to Rochester, he didn't jump into the "traditional father suit"; instead he is right behind me. When I "fall," he "picks me up and brushes me off." He can talk to me and make me feel like a quality person again. I love him for that. I feel sorry for anyone who doesn't have my father as a father. I am lucky. My father is one in a million. I mean that.

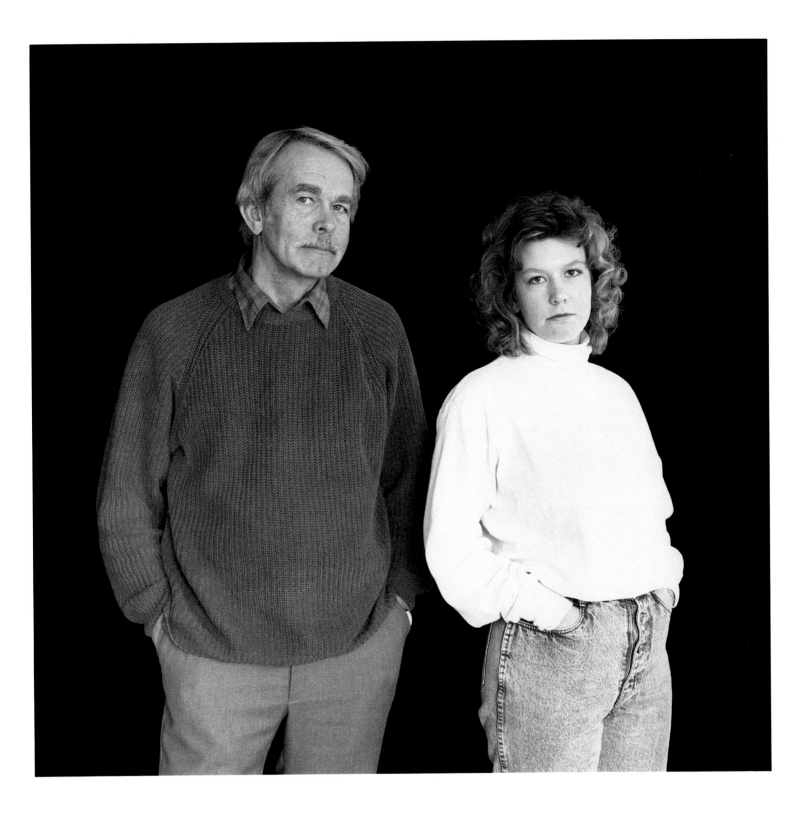

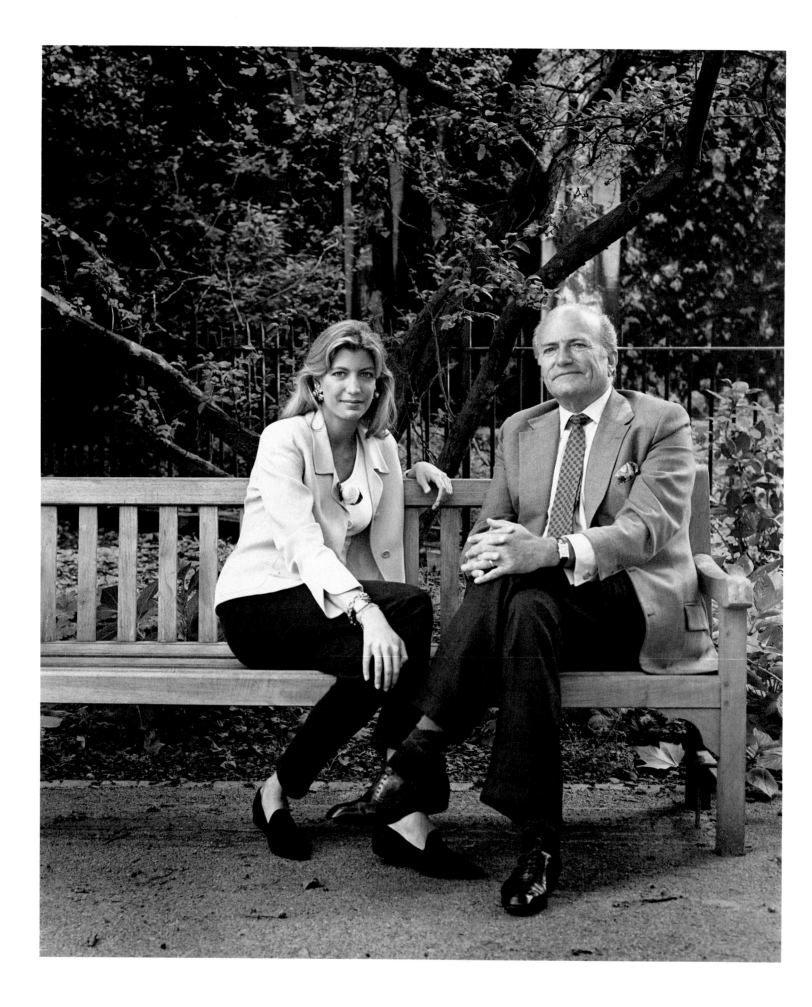

Claus and Cosima von Bulow

London, 1992

Claus von Bulow: I have now retired to Europe where I was born and spent most of my working life. During World War II, I escaped from my native Denmark and came via Sweden to England. After graduating from Cambridge University I continued my studies at the Sorbonne. I practiced as a Barrister-at-Law in the Chambers of Lord Hailsham, but was ultimately enticed into the world of commerce as an executive on the team of the late J. Paul Getty. This entailed continuous travel in Europe, the Middle East and the Far East. After my marriage, I lived in New York where my last years were marked by tragedy and stress.

Cosima graduated from Brown University with a major in English Literature and has continued her studies, since moving to England, with a Master's Degree from London University. She keeps her small apartment in her native Manhattan, but has now also bought a flat in London and rents a cottage in the country.

I chose to return to Europe because I love the old stones and the old friends who have remained loving and loyal. I was surprised that Cosima ultimately also came here. I met with adversity in the latter part of my life. She met it when her life had barely begun. For the time being I think she prefers to put the Atlantic Ocean between herself and her memories. When I see how she has developed I feel that there is a purpose to everything and that she has already met with her full ration of sorrows for her lifetime.

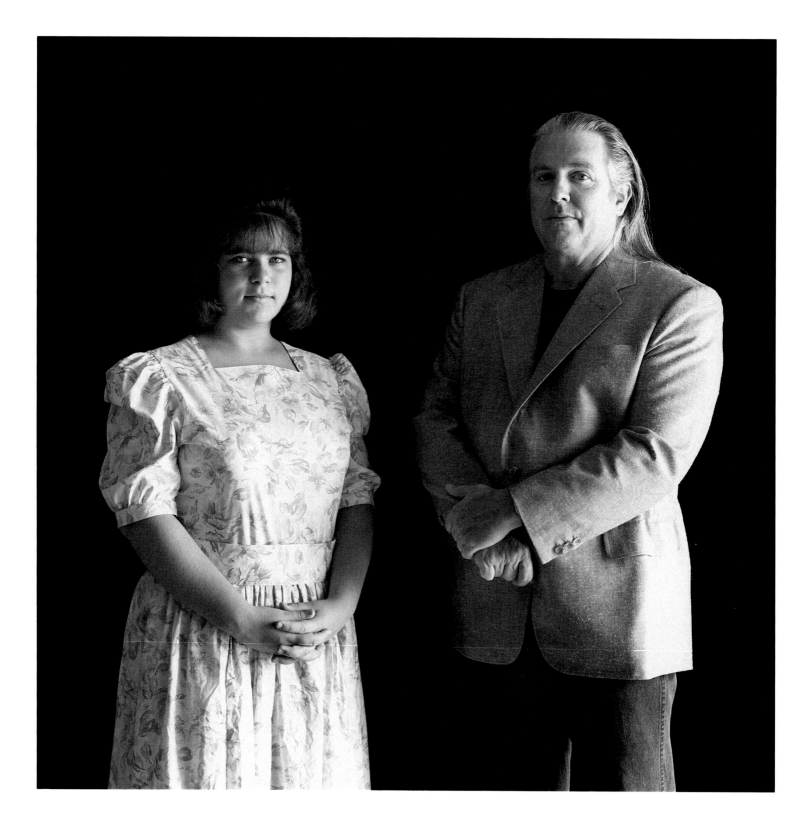

Jay and Barbara McDonald

Photography Collector
Santa Monica, California, 1992

Barbara McDonald: I'm fourteen, and I live with my Mom in San Antonio, Texas. And to be honest, I've never been very close emotionally with my Dad. Since I've become older, we've become better friends, but I think it's hard for him to imagine me growing up. I have to say that life, so far, has been anything but easy. But Daddy made it interesting. He's taken me to England, one of the greatest experiences of my life, and I hope to live there someday. He's taught me the importance of being truthful. I think he's made me a stronger person. One thing I'll always respect him for is that I know he'll give me his honest opinion. He'll say nothing out of duty or just because he's my Dad.

I must say, I'm a little nervous about starting high school. The school I'm going to is rather aloof, and I'm not, so I'm hesitant. But my Dad has faith in me. I don't think he knows how important he is to me. I really love him.

Hari Jiwan Singh Khalsa,
Sarab Shakti Kaur and Hari Amrit Kaur Khalsa

Chief of Protocol to the Siri Singh Sahib Bhai Sahib Harbhajan Singh Khalsa Yogiji,
the Chief Religious and Administrative Authority of the Ordained Ministry
of Sikh Dharma for the Western Hemisphere
Los Angeles, California, 1991

Hari Jiwan Singh Khalsa: Life as a member of the Sikh Religion and as a practicing Yogi dictates a mission in my relationship with my daughters. If one wants to leave this earth better than one found it then the obvious first step is to raise one's children to be greater than oneself. That is entry-level spirituality. Without that verification who stands credible?

My girls are my first legacy and their education is my duty. Their education includes fun, duty, discipline, devotion and faith. The way we think is fun. The way we act is duty. The way we practice our spirituality is discipline. The way we look is devotion. The way we live is faith.

As a father, my loving grateful duty has been performed when I have served my daughters so that they may serve themselves and serve others and elevate themselves unto Infinity in the Process.

Sarab Shakti Kaur Khalsa: My relationship is that you (meaning Papa) are so sweet that we go along together. We love each other and I hope we always do.

Hari Amrit Kaur Khalsa: The relationship that I have with my father is never-ending love. The values, strengths and lifestyle that he has given me will last my whole life through, and I will use them and cherish them.

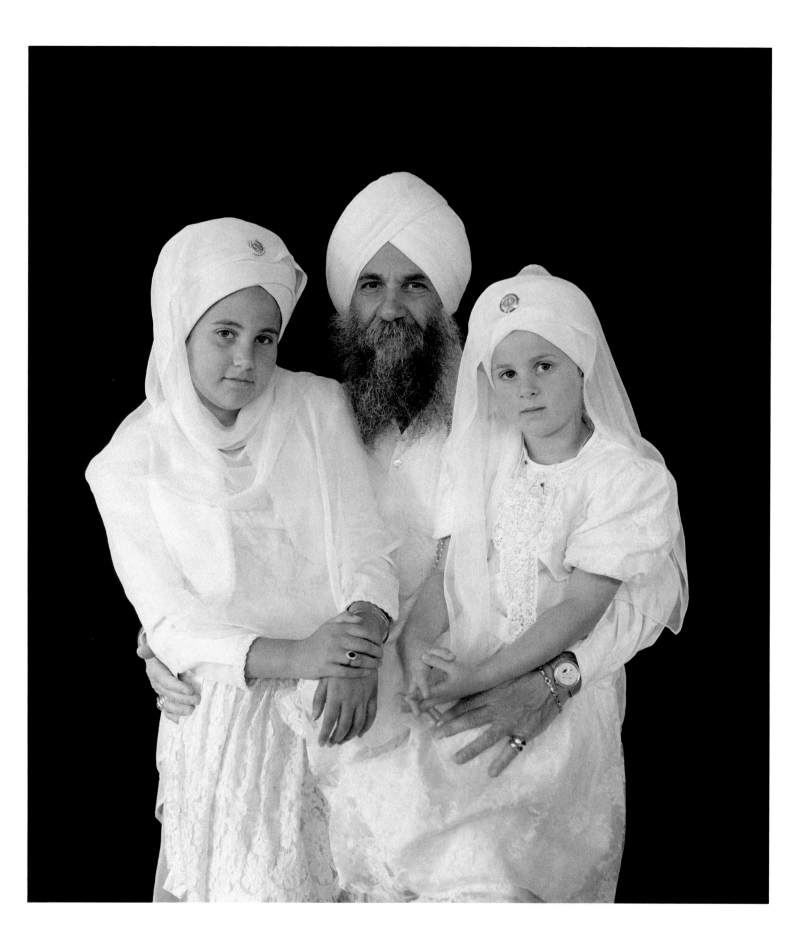

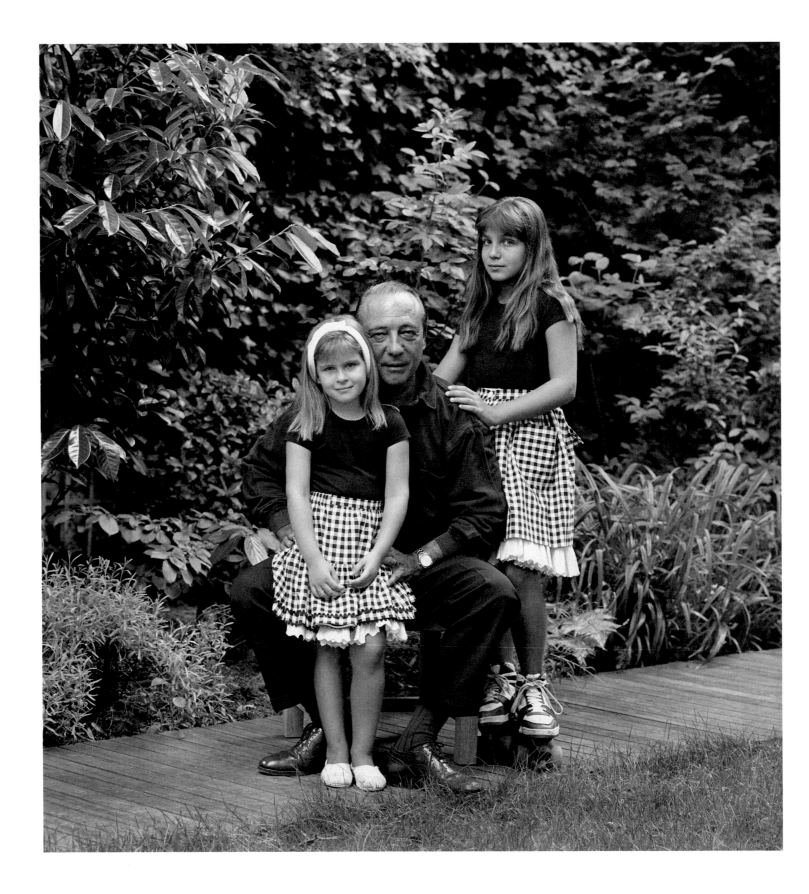

Jacques, Sara, and Lola Seguela

Advertising Executive
Paris, 1992

Jacques Seguela: Men love women, as we all know, but actually they prefer girls, by which I mean daughters. Perhaps this is the crux of love, these father-daughter relationships that transcend tenderness and affection, in which admiration, too, transcends objectivity. Do we see in them our wives as once they were in childhood, our mothers as girls again, or our sisters as they were in youth? Who knows?

Our daughters have the dual privilege of being our descendants, hence ourselves, and our opposites. Due to their burgeoning femininity they make us feminine. This is the unrecognized dream of every macho man. To have one daughter is the greatest happiness of a father's life. How lucky I am; I have two of them!

Sara Seguela: I love Papa because he has every good quality there is in the whole world. He is generous, nice, friendly, understanding and very funny.

I LOVE YOU.

Lola Seguela: My Papa makes me laugh. Every evening Papa looks out the window with me. I love him.

Isodoro and Rebeca Mauleón

Former Jesuit Priest, Professor of Spanish Literature / Composer
San Francisco, California, 1991

*I*sodoro A. Mauleón: What can I say about my precious daughter Rebeca? That she is one of the two best things I ever did in my sinful life. The other good thing, of course, is her sister Victoria.

Rebeca was the main reason for my leaving the comfortable Catholic clergy, and dedicating my life to my family and my numerous students at San Francisco State University. Rebeca has been, and is, the spiritual support of her father. Her devotion, love, patience, and her many other talents and virtues are the highest reward I can hope for until the day I die. Rebeca is my crown and glory, my staff as I walk through life waiting for the moment of Rebeca's vital and artistic plenitude.

*R*ebeca Mauleón: My father is unlike any other person I know. If I had to choose adjectives to describe him, I guess those that would be somewhat appropriate include intelligent, wise, sensitive, hot-tempered, impatient, passionate, eccentric, creative, and proud, just to name a few. His students at the University not only respect him as a teacher, but treat him with a type of love and admiration rarely seen between teacher and pupil. It seems as though I run into people all the time who are (or were) students of my father's.

For years people referred to me as "la hija de Mauleón" ("Mauleón's daughter"), but something interesting has happened lately; in some circles, people meet him and refer to him as "el papa de Rebeca" ("Rebeca's father")! Given the smallness of the Bay Area, it's fairly easy to come across the same people in either the Spanish Literature community or the Latin music community.

One of the ultimate joys of my career was collaborating with my father on several compositions, for which he wrote lyrics and I wrote the music. He is fervently committed to his writing—not one day goes by that he doesn't read or write something. I don't think he has a lazy bone in his body, which is probably why I am such a workhorse myself.

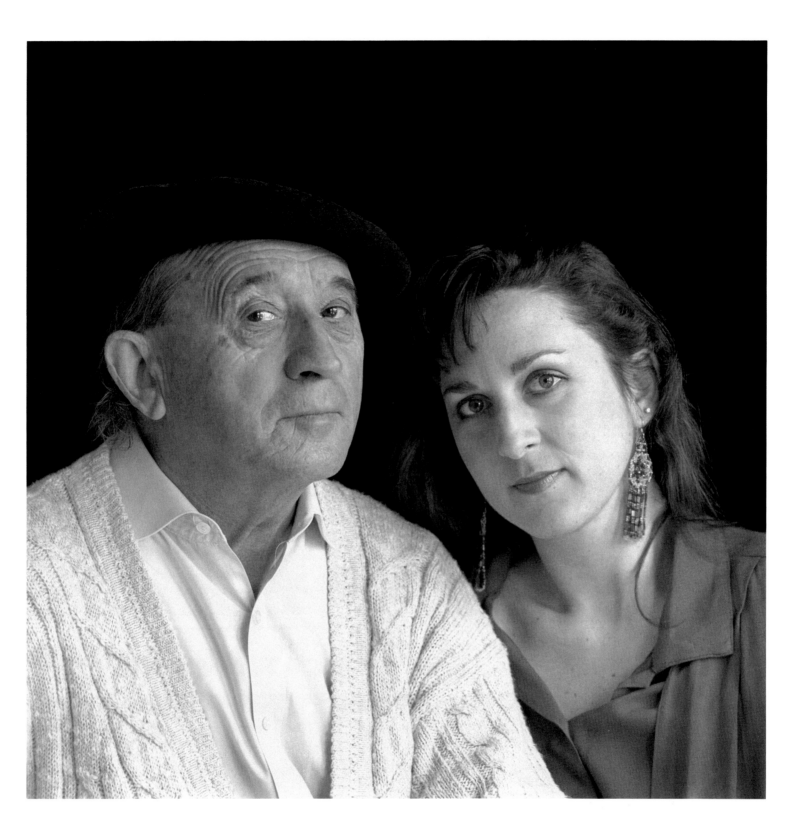

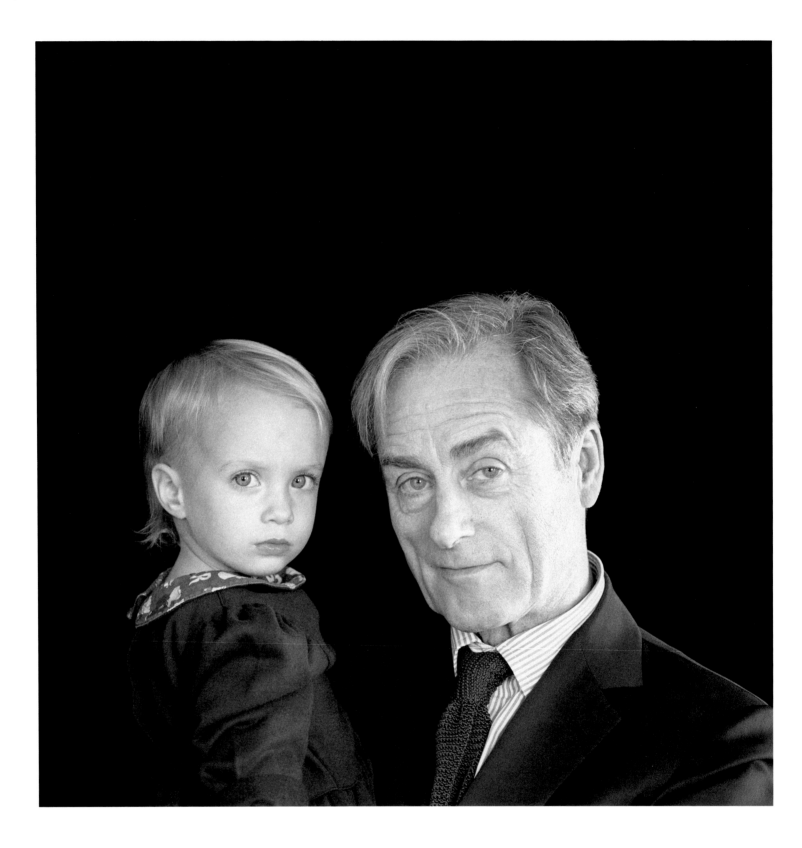

Harold and Isabel Evans

Publisher
New York City, 1992

Harold Evans: Isabel, at two-and-a-half, has a vehement sense of gender. In the evenings when she is being embraced by her returning mother, she has a stern eye for the intruding male. "You go, Daddy! Have boys' time!" Her look and tone brook no argument. Daddy and George, aged seven, are banished and march off for boys' time, which is a wrestling match between a boy and a giant centipede, interrupted in due course by cries of "Centipede! Centipede!" as Isabel suddenly hears the noise next door and rushes into the floor muddle. Boys' time, she has decided, is not as sacrosanct as girls' time.

Isabel is a very determined and focused person. She will dance with her father only if he adheres to the rules and plays "Cotton Fields" by Creedence Clearwater Revival. She has conducted a long campaign to win the affection of her older brother. He declared for many months after she became mobile that she was "a pain." Now he seeks her admiring "Wow, George!" and stoically accepts when she flings herself around his neck in an outburst of unrequited love. She has a natural sense of style. She wears baseball caps at rakish angles or her brother's cowboy boots with a sun dress. She knows who she is. "I'm not Daddy's baby," she announces, "I Mummy's baby, Daddy's daughter."

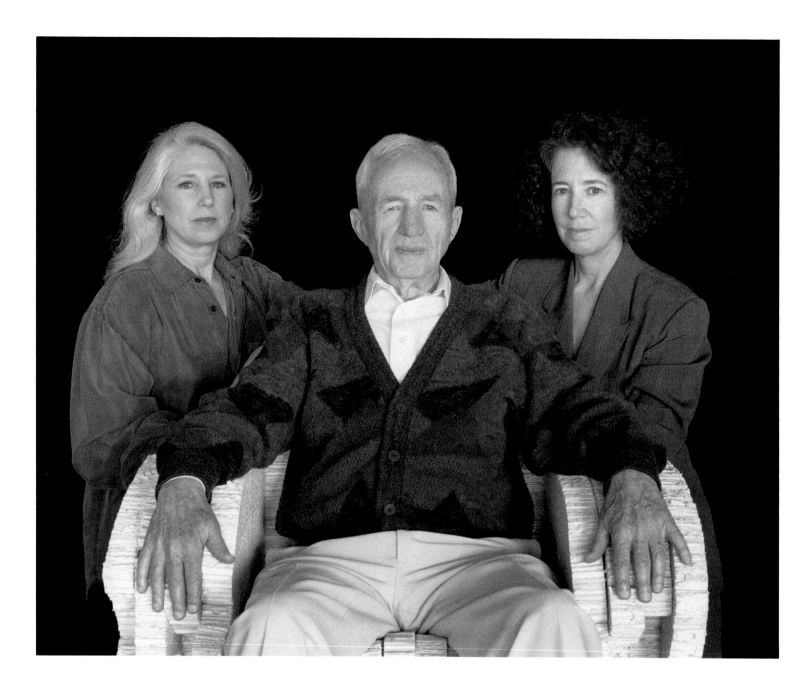

Milton, Nancy, and Alice Wexler

Psychoanalyst / Scientific Researcher / Writer
Santa Monica, California, 1992

Alice Wexler: In the days before our parents' divorce, my father began to take clarinet lessons. He also attended sculpting classes to fill the empty, anguished evenings. He never managed to produce more than harsh squeaks from his clarinet, but he did become quite a creditable amateur sculptor. He made a small sculpture of two people kissing, the man leaning deeply over the woman, and another larger figure of a seated woman clasping her knees in an attitude of melancholy. My favorite, however, was a big, awkward bas relief of two birds, the larger one carrying a smaller one on its back and flying over an expanse of water. Dad said it was inspired by an old German-Jewish folktale he had heard from his psychoanalyst, Theodore Reik, in the 1930s when Dad was training to become an analyst himself. My father said the story expressed his philosophy of the proper relations between parents and children, and he used to tell it to all his patients.

The story went like this. Winter was approaching and a mother bird with her three baby chicks began the long migration south. They flew together from Germany to the Mediterranean. As the chicks were too small to make the long flight over the water, the mother decided to carry them herself. She could take only one at a time, so she picked up the first one, flung him across her back and soared over the water. A few miles from shore, she asked, "When I am old and can no longer fly the distance myself, will you carry me on your back as I am carrying you?" The chick promised to do so, whereupon the mother bird promptly dumped him into the sea. Returning to shore, she took the second one on her back and again took flight, posing the same question. This one too made the same promise and received the same reply. Finally the mother bird picked up the last chick and repeated the question. "Well, I cannot promise to carry you on my back," he answered, "but I can promise to carry my children as you have carried me." This time the mother bird continued her flight over the Mediterranean, south toward Africa.

When Dad grew older and our mother was dying of Huntington's disease, he started the Hereditary Disease Foundation to try to find a treatment for the illness before it got my sister and me. There were no more children in our family and Dad repeated this story less often. The bas relief disappeared in one of our many moves.

Ron and Sadie Cooper

Artist

Taos, New Mexico, 1991

Ron Cooper: When Sadie was born I got my first real sense of the love I missed as a child. She and I were together for her first six years at least half of every day. She has always been a character, with her own unique thoughts and feelings and sense of style. She has a big heart and cares about people. She has lived primarily with her mother for the last eight-and-a-half years. I've spent time with her only on some week-ends and during parts of summers. It's really difficult being a part-time parent. I'm surprised at how I've had the uncontrollable urge to lecture her on morality and the meaning of things. I mean it's what you do, not what you say. She's on her way out into the world now, leaving for Copenhagen for a year of study. What a courageous thing for her to be doing; when I was fourteen I was so limited in my vision. It's almost impossible to keep up with her. She grows and changes so fast. I suppose I just have to trust in her genes and the subliminal impression her mother and I have made.

Sadie Ray Cooper: When I was confronted that I had to write about my relationship with my father, I had all sorts of thoughts and feelings. I didn't quite know how to express my feelings, or even what my feelings were.

You see, my father and mother separated about eight-and-a-half years ago, and the decision was made that I would live with my mother in Santa Fe instead of living with my father in Taos. So therefore my relationship with my father has always been sort of a week-end relationship. It hasn't all been easy, yet it hasn't all been bad. It's been a trying time. A father/daughter relationship, I think, is one of the oddest of all.

I am a very opinionated person; so is my father. That is a source of friction as well. I truly believe that I need to be on my own for a while before I can really gain respect for both my parents. But when you get through all of the little things, I must say I think my father is a great guy and I love him more than he probably knows.

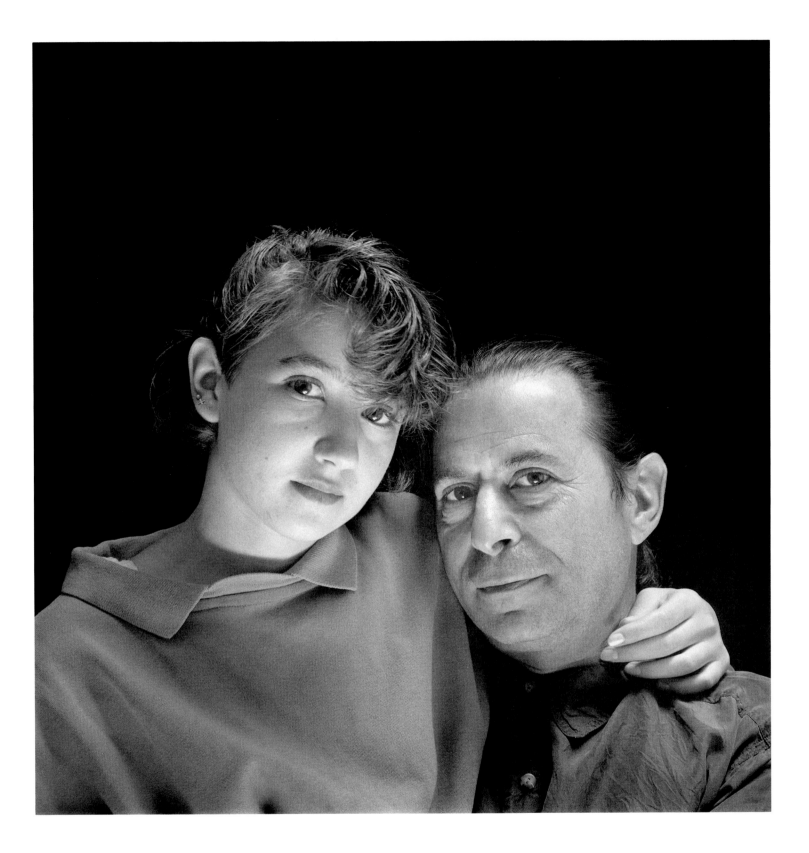

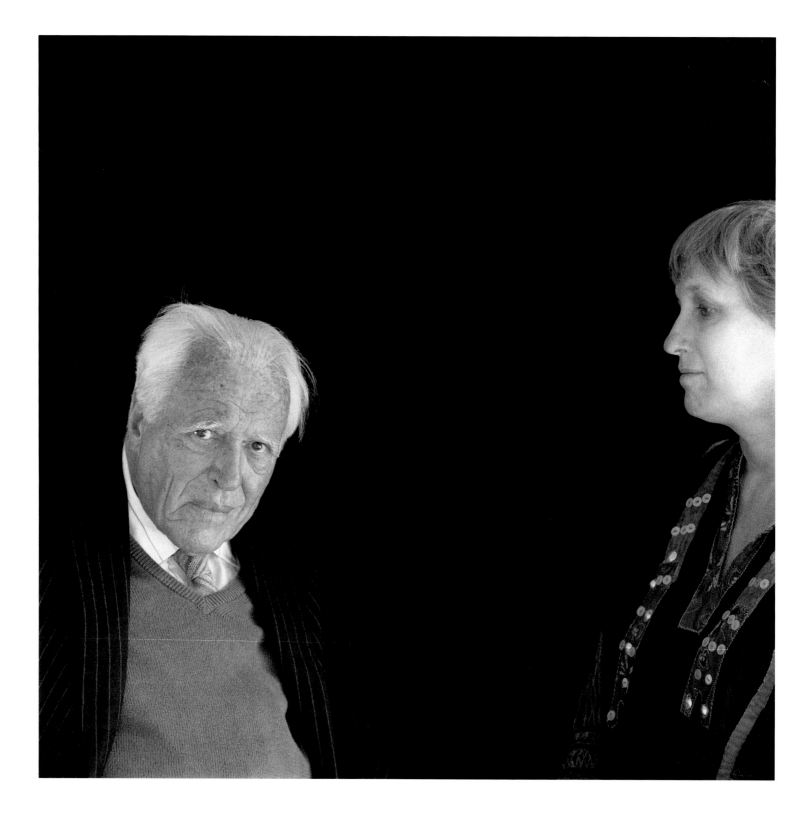

John Walker III and Gillian Walker

Former Director of the National Gallery of Art / Family Therapist
Jupiter Island, Florida, 1992

Gillian Walker: I am looking at my father. He is looking at the photographer or at an audience of ghosts. Age has dissipated the charming, powerful public persona which concealed the vulnerability of the neglected child of a bitter divorce. I am his caretaker, interchangeable with my mother, who is dead. When I was younger, I would hear him scream in terror as he woke from a dream of a woman in black who would enter his room bearing a small casket. Sometimes I am also that woman who was his mother. Otherwise I do not exist. Most of the time he is unreachable, but occasionally he is overcome with sudden tears, often about my son, who is my dead brother, who is him.

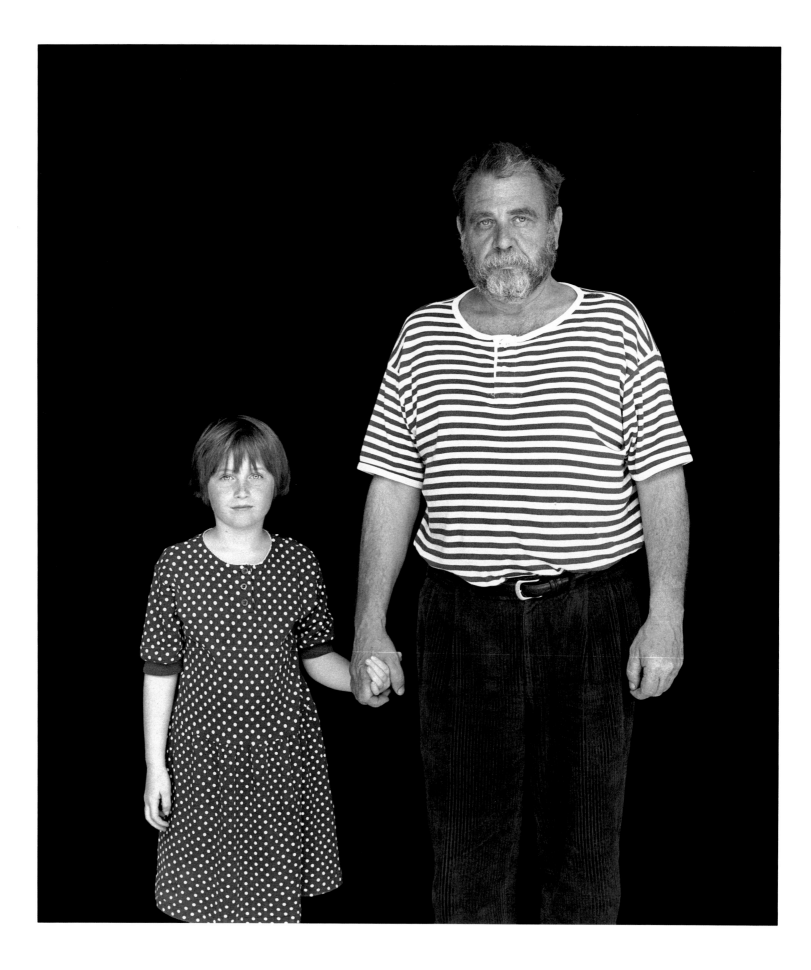

Eric and Elizabeth Orr

Sculptor
Santa Monica, California, 1991

*E*ric Orr: Very early memory, Elizabeth is about two-and-a-half years old. We are looking into each other's eyes, recognizing our joint genetic past. The chill of recognition was at once intimate and eerie. I see Elizabeth climbing a rope sculpture at age four, at the beach in Santa Monica. The rope sculpture is very large. She climbs to the top and has no fear. I'm at once proud of her self assured and fearless nature. At Cabo San Lucas we rent a small boat together. In the midst of our journey, the sail breaks. Humor and good spirits prevail. We started playing chess together when she was seven. By age eight, she was winning.

*E*lizabeth Tilbury Orr: When I was three or four, we often drove to Aliveras Street. It was very fun and it is like Mexico. My Dad would always have fun. It was like non-stop every day. Now my Dad cannot see me or my brother very often, but I think I understand. My Dad is in the Venice Artwalk every year. I help with the lemonade stand and decorate his cards and while I am decorating, I listen to the jokes he tells while talking to the audience. I've always liked how my Dad is fun, exciting and always getting new ideas.

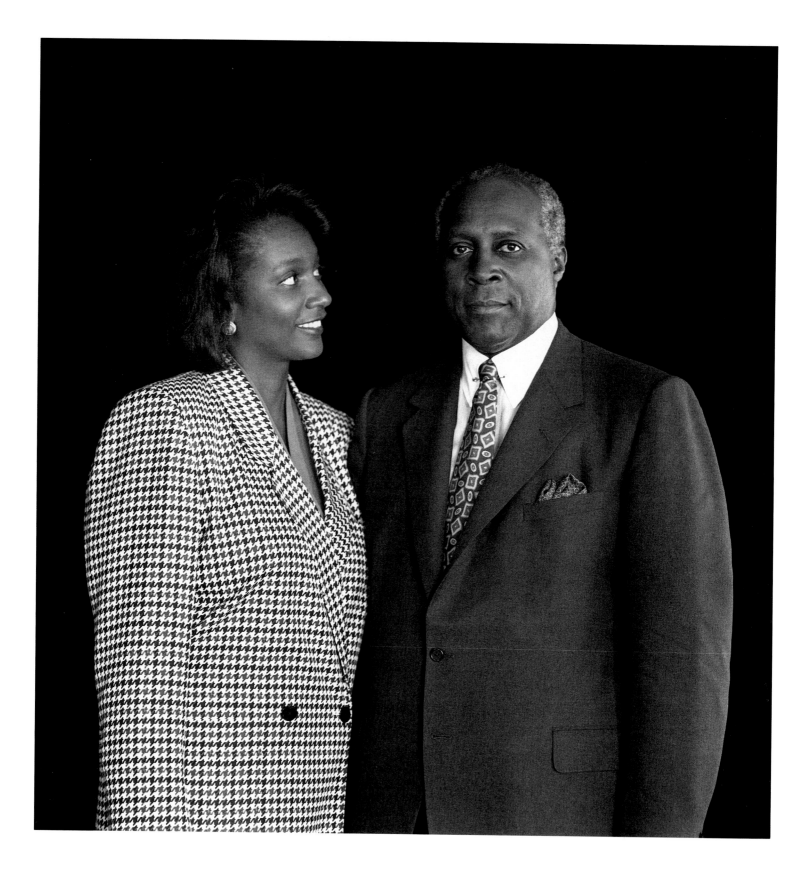

Vernon Jordan, Jr., and Vickee Jordan Adams

Attorney / Communications Trainer
New York City, 1992

*V*ernon Jordan, Jr.: As I did the customary early morning pacing of the hospital corridor, wondering whether my first-born child would be a girl or a boy, the nurse finally came out with the good news of a baby girl. There was joy in the morning, a fresh breeze of future gladness and promise.

I vividly remember looking through the window at my newborn child, Vickee Sharee Jordan. I remember the excitement: I waved frantically at the tiny bundle whose eyes were closed tightly, whose little body was exhausted with the effort of coming into this world.

And it's been great fun watching her grow, develop and mature. Each new development is a landmark in our personal histories: her first step, her first spoken word, her first day of school, the first vacation, the first young man to come calling, summer jobs, high school graduation, college and the world of work.

Our first joint venture was unplanned and unannounced, yet well implemented. Somehow we both knew that her mother, Shirley, stricken at a young age with multiple sclerosis, was an independent spirit. In that period we formed a friendship and partnership that has stood the test of time. Our role was to reinforce and encourage that independence so as to avoid total dependence. We were successful.

Our friendship was forged out of Vickee's rebelliousness—"Why can't my mother walk like the other mothers?" "Daddy, why are you always screaming at white people?" "What is the NAACP anyway?" "Why are you speaking at my graduation? Why can't you sit in the audience like the other fathers?" "I'm not eating meat anymore."

That rebelliousness was acted out in other ways: returning home from the eighth grade trip to Europe with an Afro hairdo; deliberately forgetting her lunch money to qualify for the free lunch program; urging her parents to skip PTA meetings; refusing to be seen in limousines; managing the freshman football team her first year at the University of Pennsylvania; and protesting her father's invitation to give the commencement address. These rebellious acts resulted in discussion, debate, understanding and friendship.

Now married to a private banker, Barry, the mother of a two-year-old son, Jordan, and a Vice President for Media Training and a member of the New York management committee of Ketchum Public Relations, she is still my rebellious daughter, leaning toward establishment ways, my friend whom I love dearly.

Vickee Jordan Adams: People are always amazed at the way I tease my father. They like to see the way we smile.

I remember him in the kitchen, fashionably aproned, preparing blueberry pancakes for my mother and me, or frying up a batch of porgies, cheese grits and biscuits as a midnight breakfast for a group of "prommed out" high school seniors!

My father has addressed each one of my commencements—that means kindergarten, elementary school, high school and college! Imagine the impression he made on 20 five-year-olds in the Atlanta University Homes Nursery School!

When we sat in the limousine outside the Metropolitan AME Church in Washington, DC, watching the guests for my wedding arrive, he was as excited as I was. No one could tell who was more nervous as he gave me away to my husband, Barry: the bride or the bride's father.

And now that he is a grandfather to young Jordan Monroe Adams, I can't help but adore and smile at the man who—between meetings with heads of major Fortune 500 companies—will stop by our home to make goo-goo noises and dance the hokey-pokey with great vigor.

He is my best friend. I've never lost faith in that belief. I tell him everything. He's a truly amazing man. He's my Daddy.

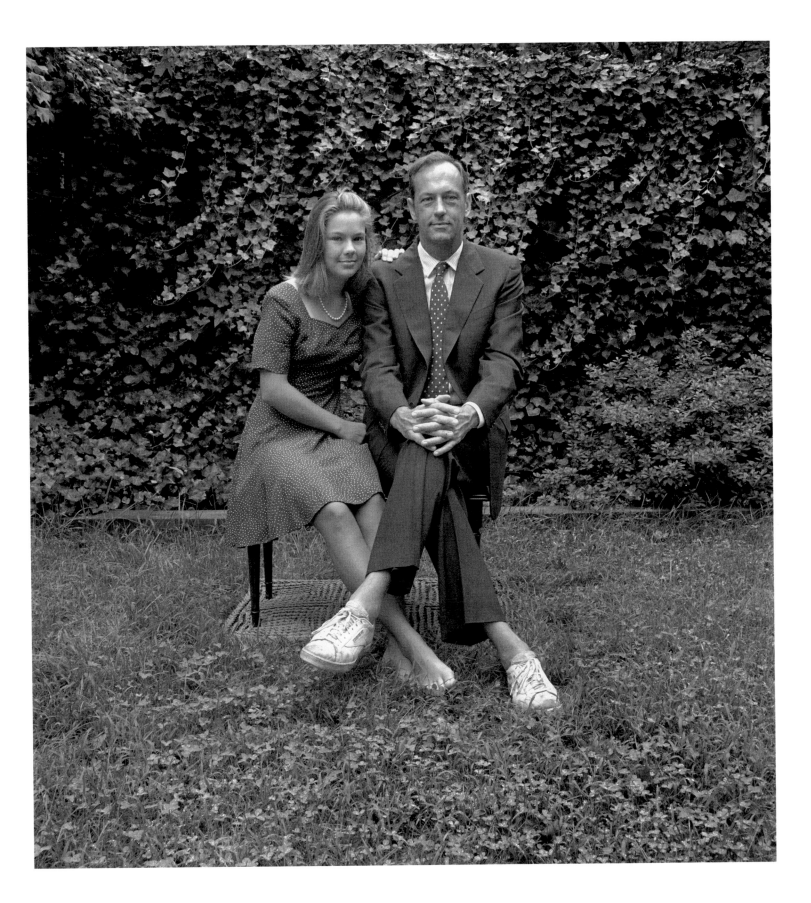

Senator Bill Bradley and Theresa Anne Bradley

United States Senator
Washington, D.C., 1992

John A. Cook and Mariana Cook

Psychoanalyst / Photographer
New York City, 1990

*J*ohn A. Cook: Having a daughter is an overwhelming experience of the present and what the present might bring into the future. My experience of "Mimi" is emotional, an envelopment. I don't think of her in the sense of thinking. I feel wonderment, love. It's not an intellectual experience. It's not analytical at all.

In looking at my eightieth birthday balloon, there came the imaginings of the future. There were many and to some degree they were so high falutin' that I was amused at the extent of the dreams that the balloon represented; their very great excitement and yet at the same time, their total secrecy. The future becomes very much alive when I am with my daughter, but at the same time I have to realize that in the future and in reality, I will no longer be there. There's a certain wonderment that she will be there.

The future is what we wish, what we predict. Is it true? Do we take with us the people we think of? It's strange to think of the future and to be sure that it will happen when simultaneously one knows that this is not possible. Very sad.

When I think of my future, I think of clouds more than anything else. When I think of my daughter's future, I see specific successes, something glorious. God bless her.

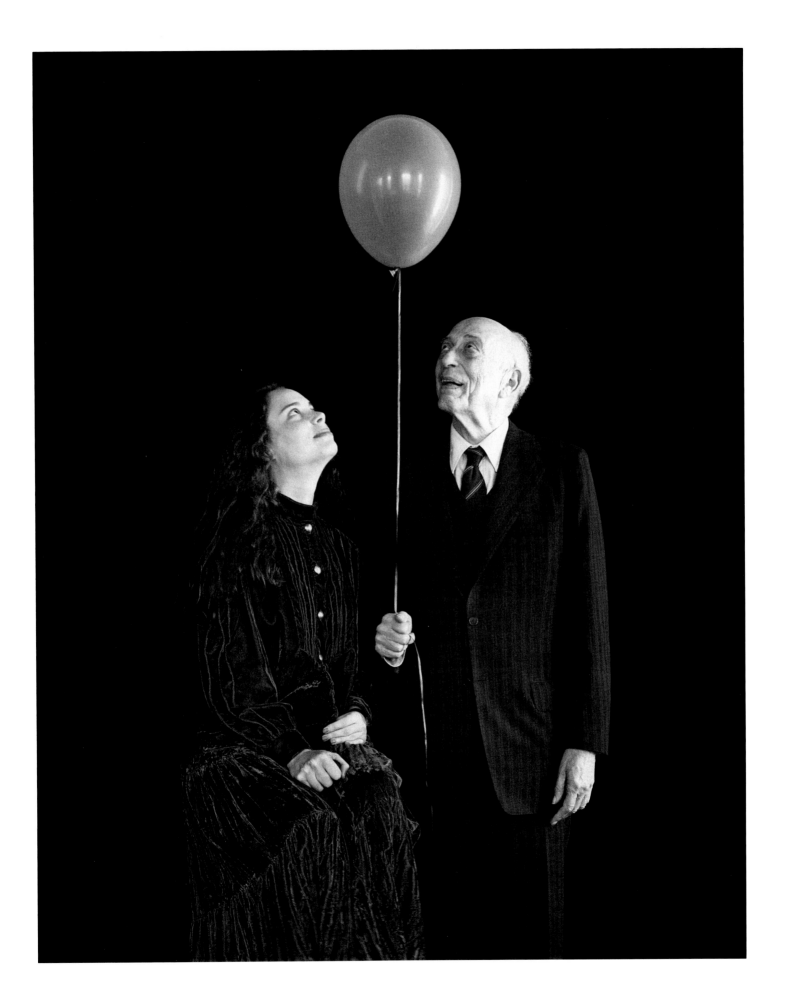

Afterword

To bring this book to a close is difficult because it also marks a closure in my life. My father and I adore each other. We always have.

As a child, Dad drove me to school every day. We would look out the window and talk about the people we saw. I knew my father was a psychoanalyst, but wasn't quite sure what that meant. I began to understand better as my father described his perceptions of the people on the street as, "Paranoid," "Self-impressed," "Exhibitionist," "Depressed," "Powerful," "Loving," or "Self-fulfilled." Perhaps more than anything else, I was struck by the fact that Dad did not differentiate between the men and the women. Both a man and a woman could be described in the same way. I had had the preconception that boys and girls were totally different from each other. I learned from my father that character traits transcend gender. I wanted to be just like him.

As I entered adolescence, Dad and I read Freud's *General Introductory Lectures* together. That venture marks the only time I recall his losing patience with me. I had difficulty understanding the definition of the "Unconscious." I kept on calling it "Subconscious." I resisted Freud's revolutionary idea that people's lives are dictated by psychological constructs beyond their control. I would like to think that I finally understand, though to this day I'm not sure I accept it!

In 1990, as my father approached his eightieth birthday, it occurred to me that he could not live forever. My best friend was aging. I became fascinated with every father and daughter I saw. I was anxious to understand their feelings for each other and wondered if their experiences were similar or different from ours. These pictures were made as an exploration.

I have discovered that fathers and daughters have a mysterious bond, but the variety and complexity of that bond leads me beyond generalization. No two relationships are alike. Each love has its own roots, its own destiny.

It is natural for a daughter to outlive her father. And yet, somehow, it is not fair that my best friend of so many years should have no choice but to leave me. My father loves pictures as much as anything in the world. And so, I make photographs for him, wherever he may be—always in my heart.

Mariana Cook

List of Portraits